Forever Wandering

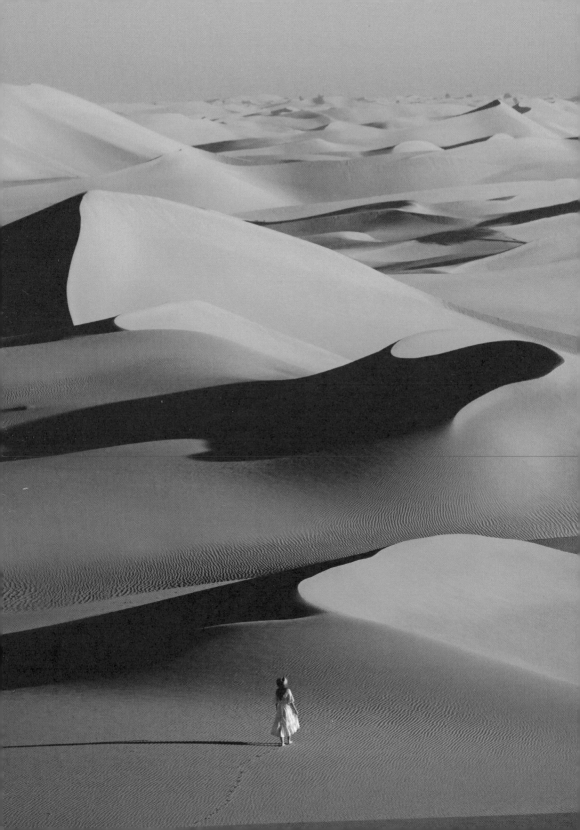

Forever Wandering

Our natural world through the eyes of Hello Emilie

Emilie Ristevski

Hardie Grant

TRAVEL

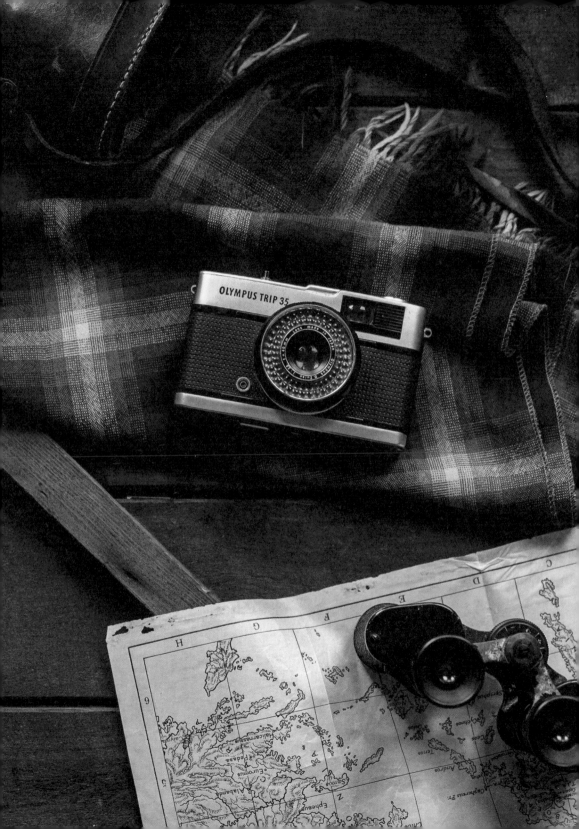

To the wanderers and those wild at heart ...

I invite you to see the world through my lens; a place filled with curiosity and a glimpse into the unknown. The otherworldly landscapes found throughout these pages offer a tiny peek into the endless beauty our planet holds. Our home is filled with immense diversity, from the vast desert landscapes in Namibia to the frozen glacial icecaps in Greenland. These are the places and experiences that have led me to where I am now, and it is the fragility found here that has led me to so many unanswered questions. The further I wander, the more I learn – not only about the world but also about myself.

With all honesty, I feel I owe our planet Earth so much. Wandering far and wide has opened my eyes, heart and mind. Amongst the valleys, mountains and wide-open spaces is where I have learned the most from nature. There is a stillness only found within these living landscapes – a quiet moment to inhale and exhale. I let my mind wander freely within the vastness and take in nature's ever-changing beauty: the last moment of light disappearing beyond the horizon; autumn leaves completely transforming the landscape as they change colour; storm clouds filling an entire valley before my eyes. It was in these moments, immersed in nature, that I discovered the raw and unpredictable ways of our planet. Nature is forever changing and growing; the constant ebb and flow and uncontrollable impermanency is a powerful reminder of Earth's transformative cycles. Our planet's vast landscapes have also shown me how tiny we all really are, and I find an overwhelming feeling of insignificance and wonderment when standing on a mountain-top or looking at the night sky in a vast desert. It is beautiful yet at the same time frightening to know that so much is beyond us.

Our planet may differ in so many ways, but at the heart of it I have learned we are all fundamentally alike. No matter where we are from, we all share the same home – we all look up at the same sky, the same sun and the same moon. Our natural world is a place that always feels familiar, even if you've never been to that specific place before – a warm sense of comfort and belonging that resonates within you when you connect to nature. It's a feeling you find hidden deep within your bones. Nature transcends all our differences, and when we look closely we can see how truly

interconnected we are with all living creatures, sharing this magical biosphere as one.

Nature is essential to our human spirit. It is a direct connection to our very existence, an intrinsic relationship that unites us and which we inherently depend upon. Our natural world sustains us and provides for us in every way: the air we breathe, the water we drink and the food we eat. There is always a way to reconnect to our living home, a place where we all truly belong. I don't have enough words to explain my own connection with nature – the beauty of our sky, the spirit of our land and the depths of our oceans. Our planet inspires me and fills my heart, yet leaves me feeling vulnerable and completely in awe with our existence.

Always being in motion, I travelled throughout some of the most unforgettable parts of our planet – places I never even knew existed. Standing within some of the most remote and harshest landscapes and seeing their fragility led me to ask myself deeper questions. I started to ponder what the future will hold, and I wondered if the coming generations will always be able to experience such sights, or if these fragile pieces of our world will end up only existing in books and photographs. It is through these very experiences that I became awakened to the impact of our choices. I began to realise how even the tiniest of things can create ripple effects and that so many of us exist without recognising how inherent nature is to us, and how interconnected our relationship with nature truly is.

I saw the paradox that surrounds travelling to appreciate our diverse landscapes, and the effects this travel has on the natural world. I even began to question myself and my own intentions: why I choose the things I do in life and where my career path has taken me. I saw the consequences of our current way of life and could not ignore the guilt I felt from travelling so extensively, knowing the enormous impact it has on our environment. In a world that is under threat, I began to question how I can love this beautiful planet of ours and continue to photograph our natural world without also feeling the need to protect it.

Left feeling at odds with myself, I knew that each choice I make has a consequence. As travel became overwhelming, I started to learn how to slow down and began to search for a new path in our ever-changing world. While these thoughts began in some of the most unexpected places around the globe, it was slowing down and being still at home that allowed me to see the bigger picture, and in recent years I've consciously made the time to pause and reflect. By choosing to travel less, I was able to give myself time to focus on

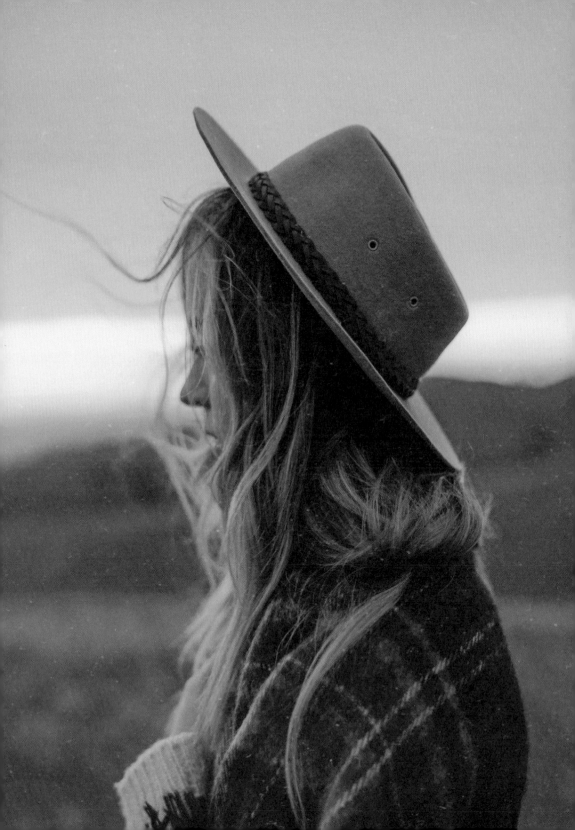

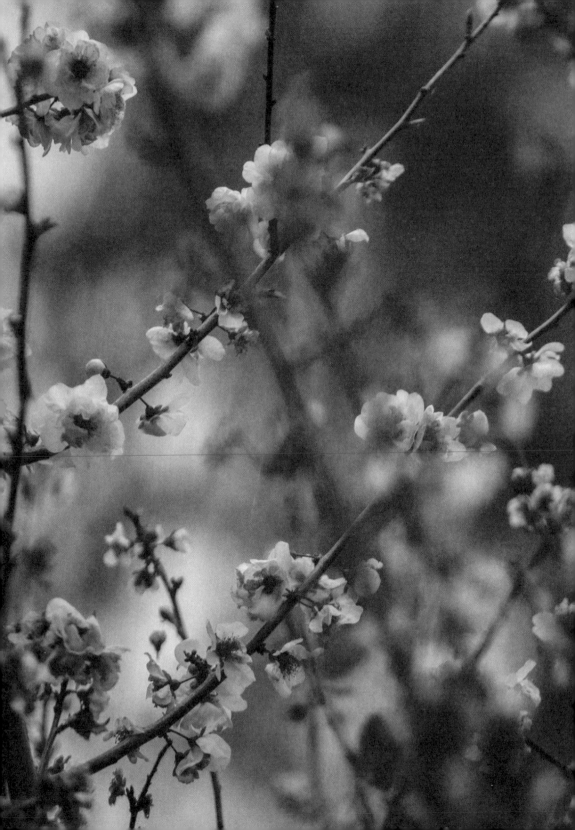

the things that are close to my heart. Consequently, travel became much more meaningful, and the new perspective I'd gained reminded me to travel mindfully, always being aware of the impact of my actions and choosing the path that treads lightly.

With pieces of my mind and heart scattered all over the globe, I've felt the urge for my images to do and say more with the hope that I can encourage a greater awareness of our Earth's beauty and also its ever-present fragility. Nature has taught me to keep an open heart, how to live with less and to always find gratitude in the smallest of things. It has shown me the importance of staying curious and the power of letting go. Seeing the harmony and balance only found in the natural world and how each and every part is connected to form the larger picture, I've realised that this connection can be found all around us when we choose to look – not just on the other side of our planet but within our own surroundings. I began to see that we don't need to wander far at all to appreciate the beauty in the smallest of things – light beaming between the clouds to form shadows, the path of raindrops falling on a window, tall trees leaning in the wind. I am always learning from nature – understanding how to live in harmony, how to be still, how to give freely and only take what I need. I'm forever learning how to truly live at one with nature, in the hope that we can leave a vibrant planet full of abundance and life for all.

I hold an immense gratitude for having seen so much of our beautiful planet; wandering far and wide and encountering the unknown has allowed me to experience things I would never have dreamed of. The moments documented throughout each of these pages have led me to see our planet in a new light, and by reading these words and immersing yourself in my images, I hope I can transport you into the wilderness of our beautiful world and help you discover a depth of wonder and awe for our planet. I hope these pages will inspire you to re-ignite your connection with Earth and see the beauty that is hidden within every corner of our planet.

To always learning, always growing, forever wandering within and without …

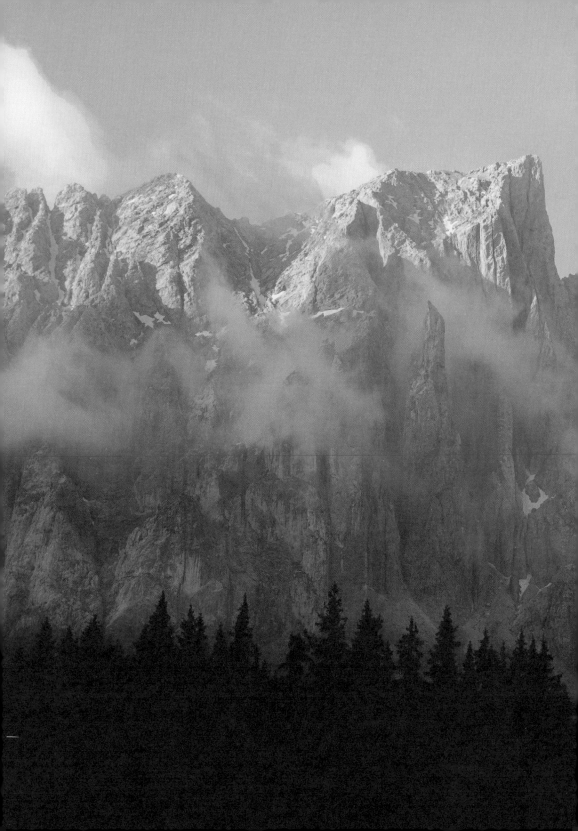

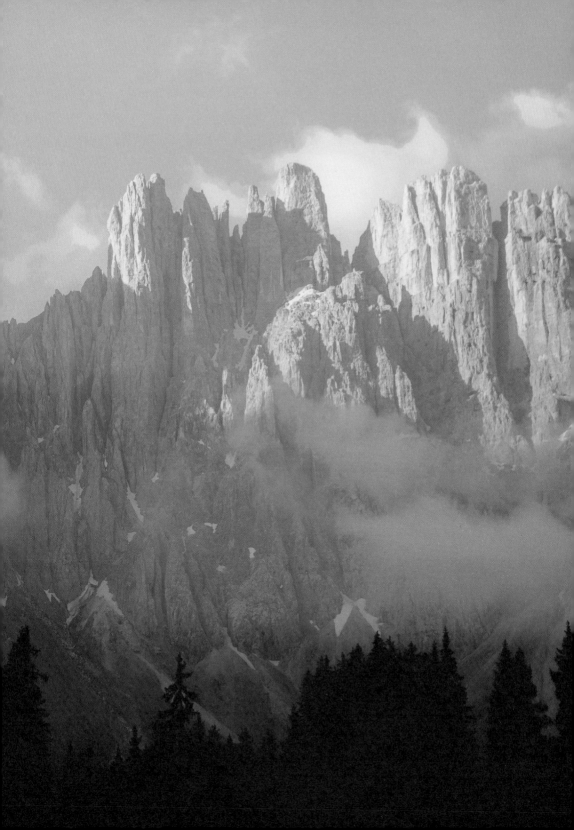

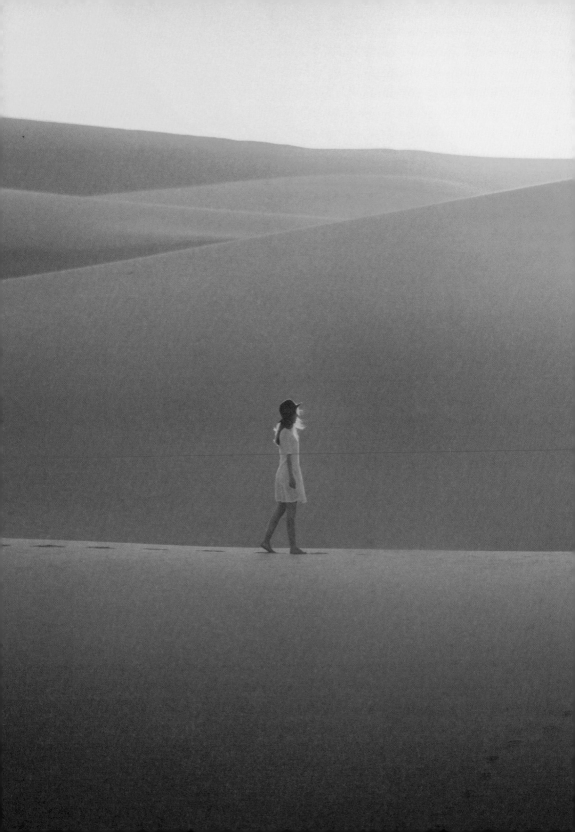

A world filled with curiosity and a glimpse into the unknown ...

Explore the unknown to discover a greater awareness of our world and ways to conserve and capture the details that often go unseen

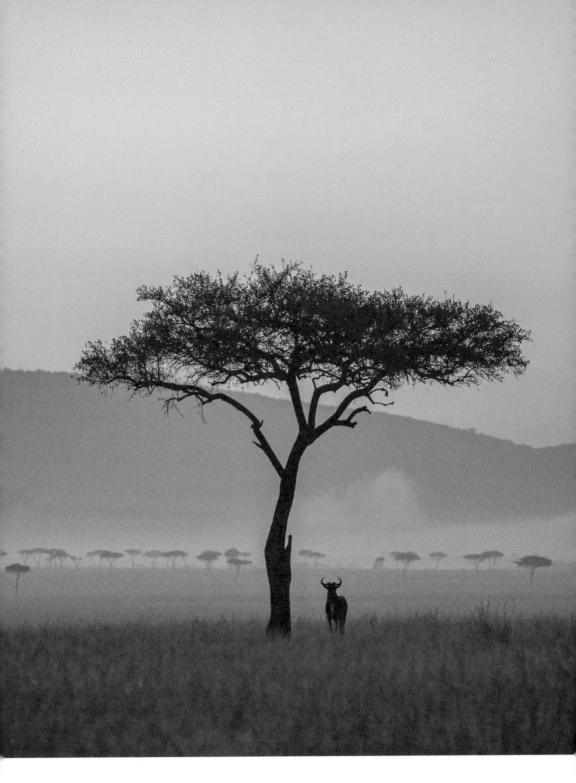

A lone wildebeest wandering through the grasslands in the early morning mist – thriving in its natural habitat. Maasai Mara, Kenya.

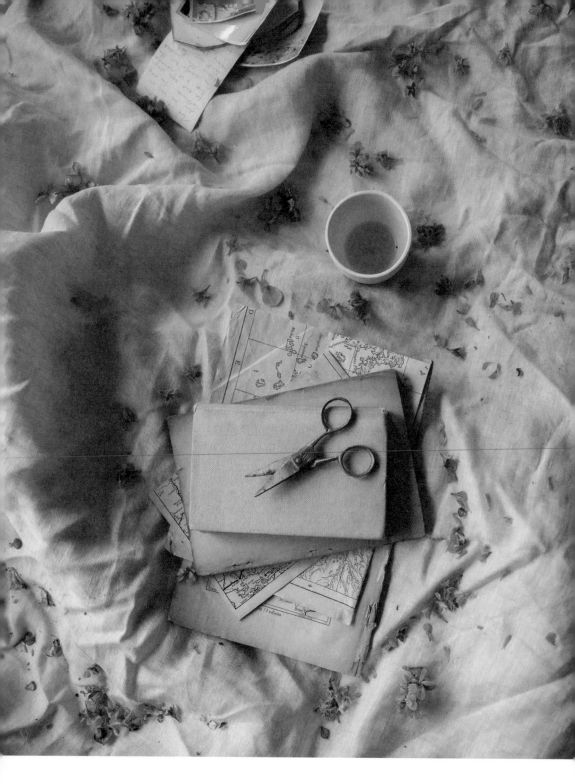

Delicate moments of calm to let your mind escape to the hidden universe we all hold inside ourselves

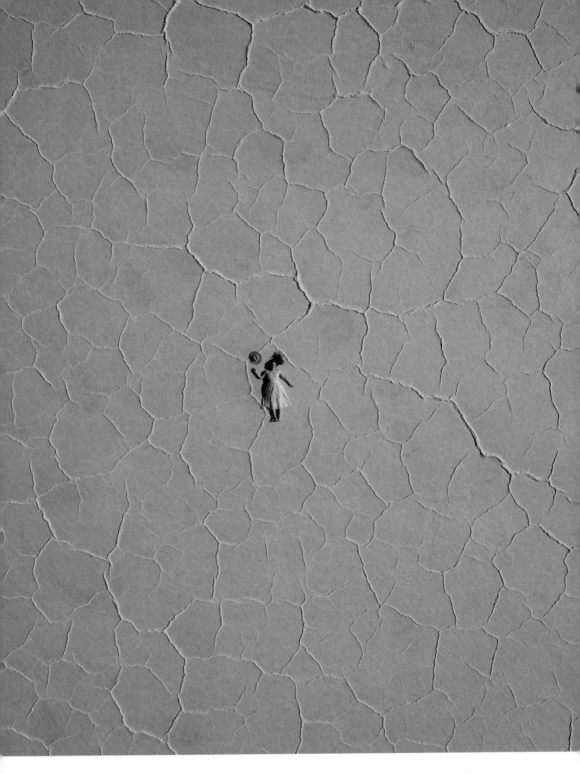

A new perspective can uncover hidden textures and patterns of our sacred earth and reveal the vulnerability found within these ancient landscapes. Lake Amadeus, Australia.

17

Endless patterns are woven into the surface of the earth. There is beauty to be found in the most unexpected of places.

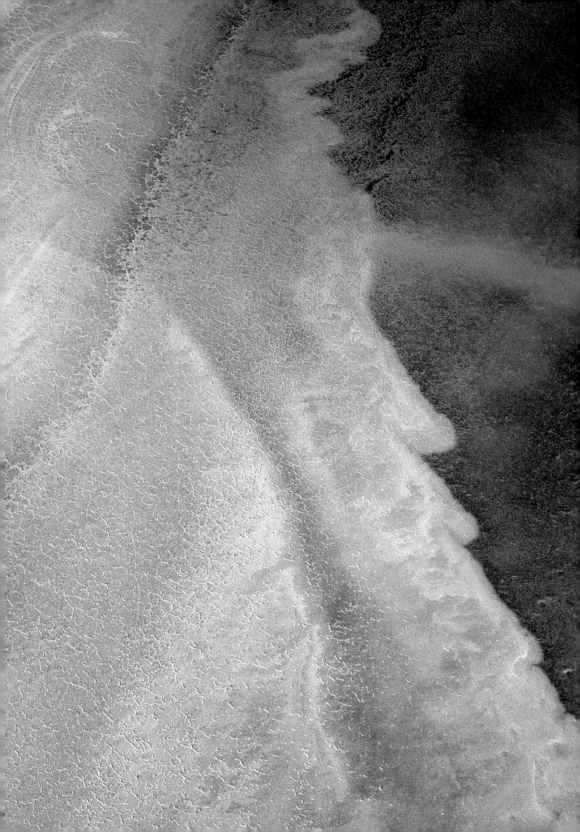

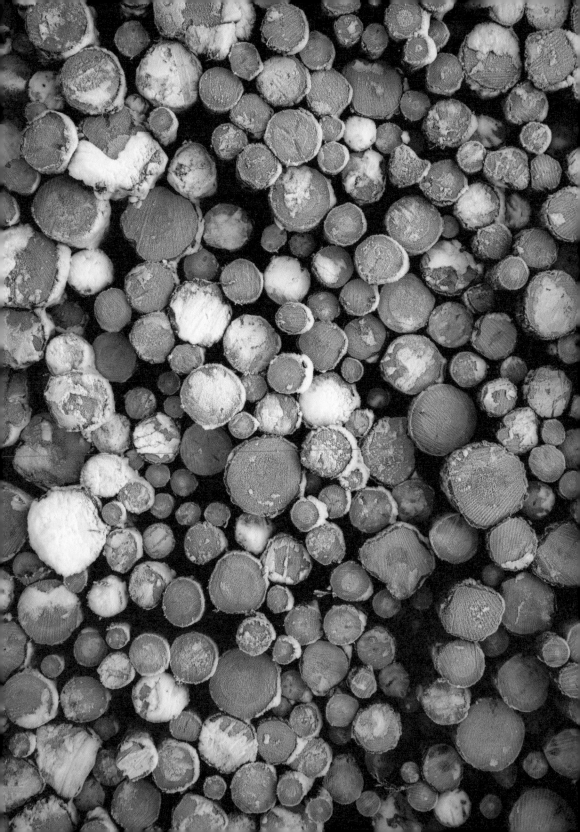

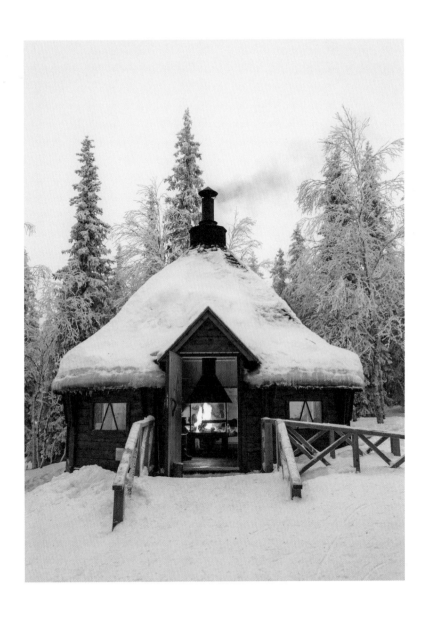

Left Snow-covered woodpile in the depths of winter. Lapland, Finland. **Above** The comfort and warmth of a fireplace inside a Finnish wilderness hut, secluded deep in a white winter forest. Lapland, Finland.

An embodied spirit lives within the Namib Desert.

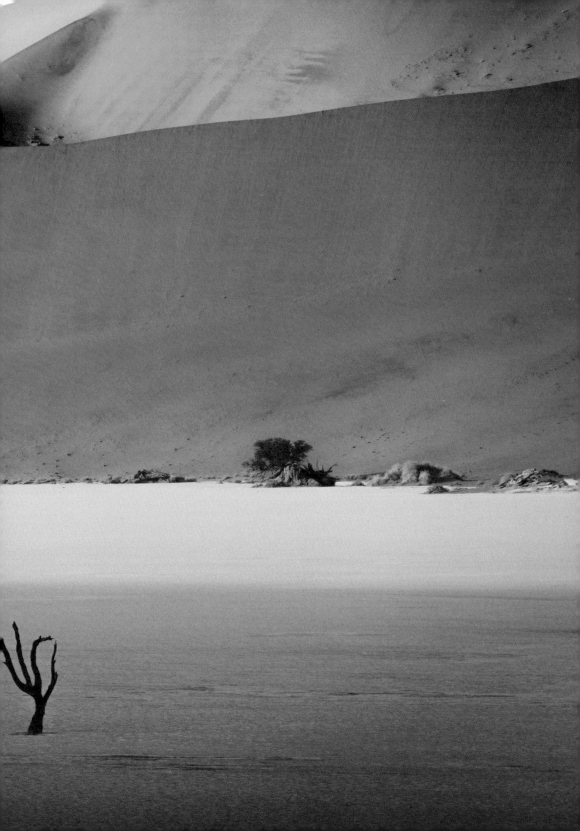

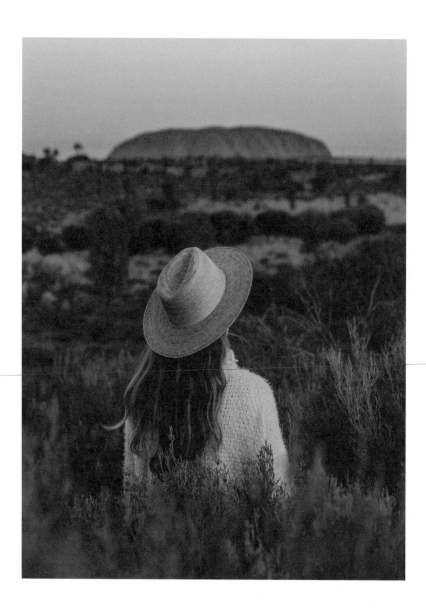

Above When the dusty pastel pinks and burnt oranges of the sunset fill the entire sky, an indescribable sense of magic comes to life in these ancient landscapes. Uluru, Australia. **Right** Hidden deep in the Red Centre, the remnants of a prehistoric sea can be found. From above, these transformed desert salt lakes are filled with the most beautiful colours and patterns. Lake Amadeus, Australia.

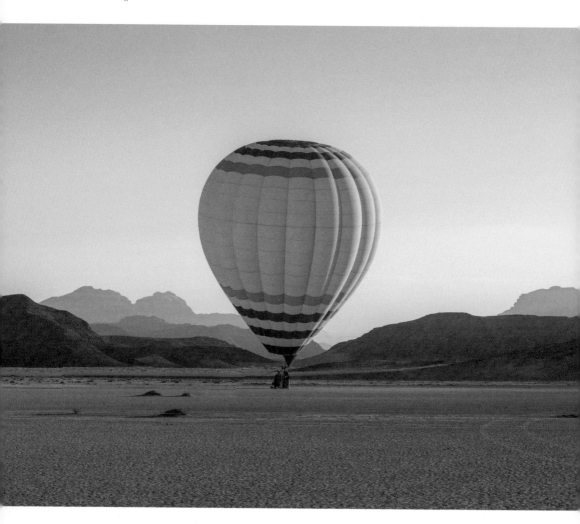

Imagine floating high above the vast desert plains, observing the way this landscape slowly transforms from dry, rocky desert into the majestic mountains of Wadi Rum, Jordan

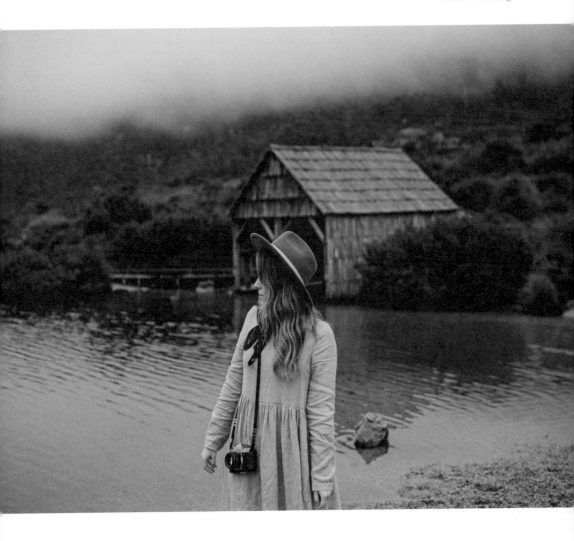

Wander to the places where you feel most alive. Early morning mist covering the surrounding landscape in a veil of mystery. Dove Lake, Australia.

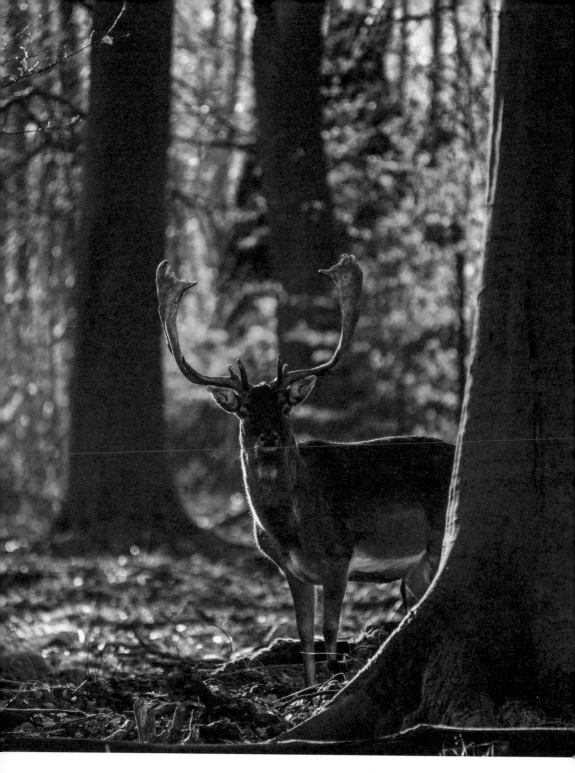

Embrace the wildness in each and every moment you encounter. A fallow deer wandering between the ancient oak trees and bright autumn leaves. Jægersborg Dyrehave, Denmark.

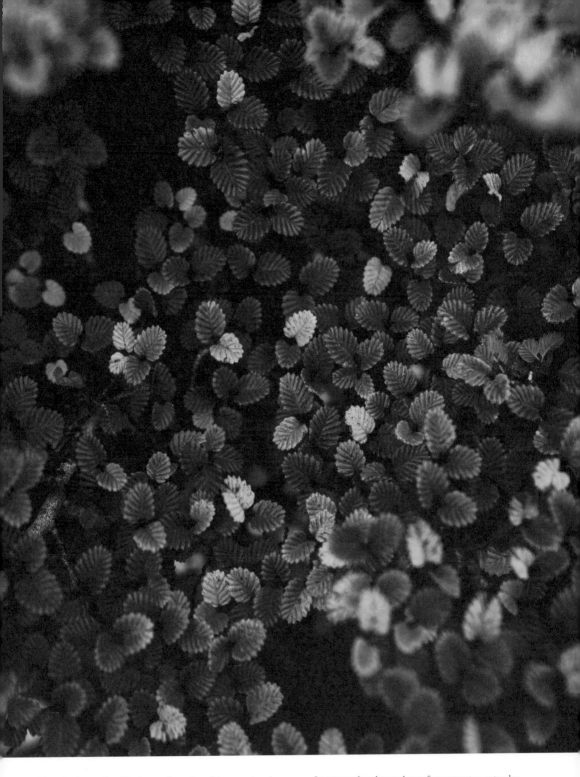

There is a beauty found in the transformation of the ever-changing seasons. In autumn these leaves change from green to spectacular shades of yellow and rich reds and browns. Tasmanian Highlands, Australia.

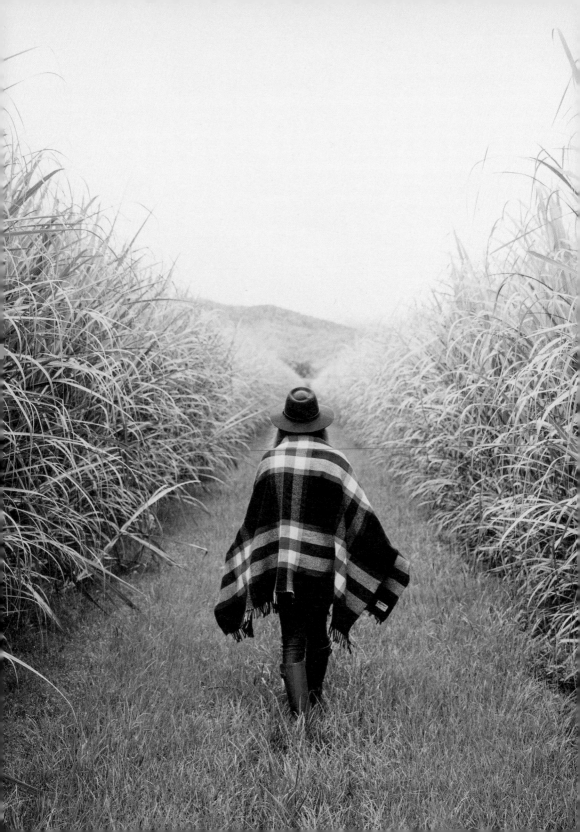

Listen to the whispers of nature and you'll learn that everything has a story.

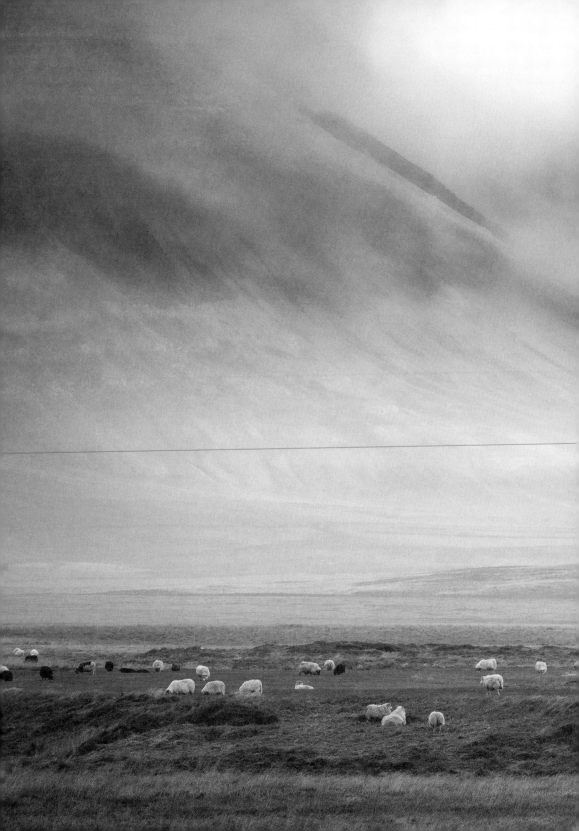

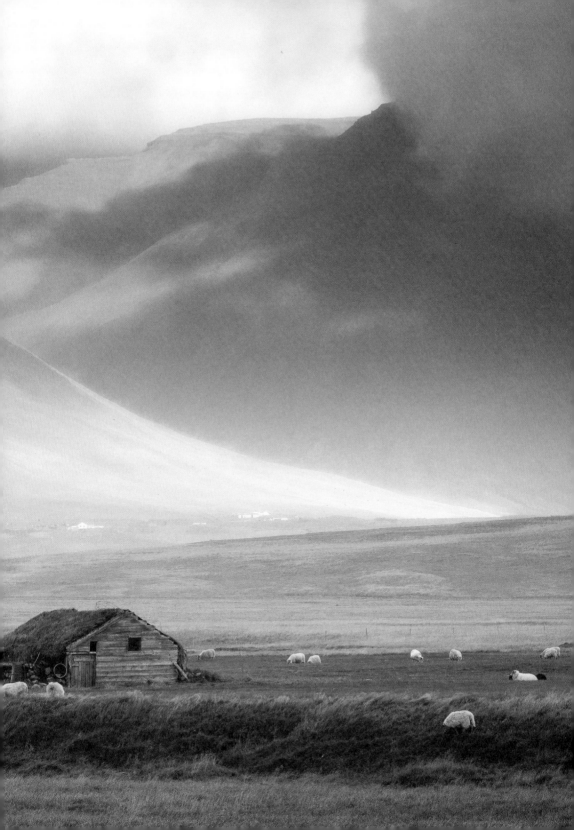

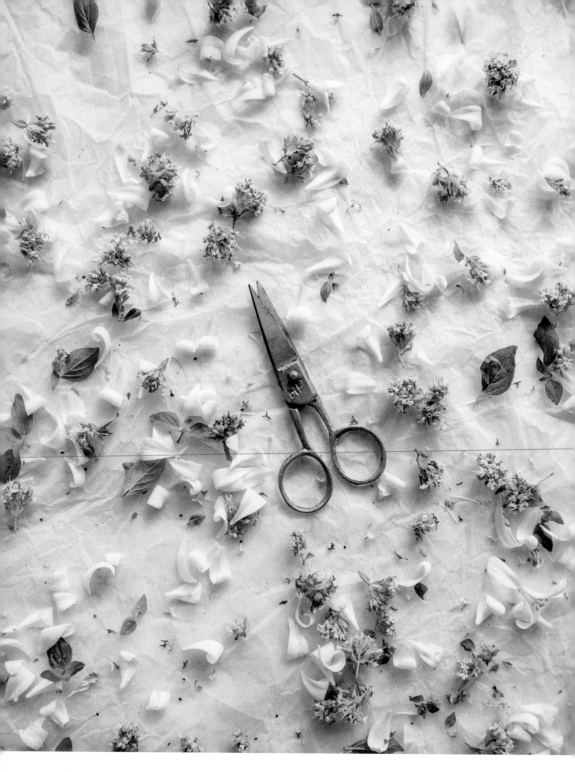

Previous Living as one with nature. Sauðárkrókur, Iceland. **Above** Gathering and collecting are simple acts that can help form our memories and imagination, re-igniting our connection with the natural world

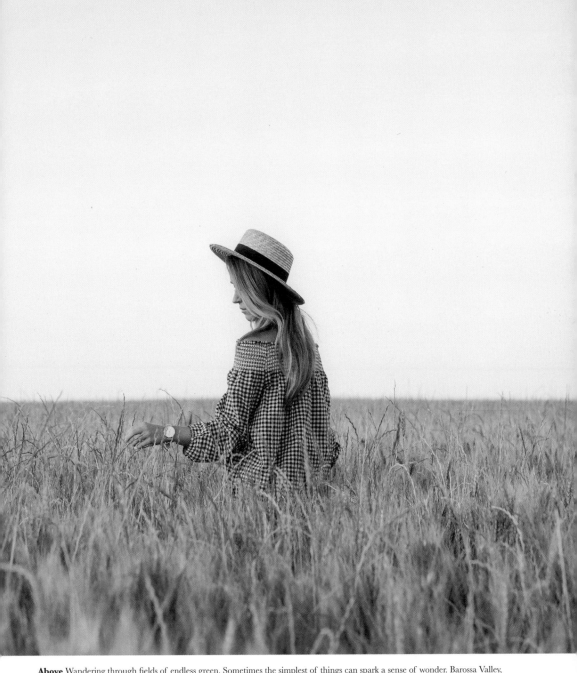

Above Wandering through fields of endless green. Sometimes the simplest of things can spark a sense of wonder. Barossa Valley, Australia. **Overleaf** A brief moment of alpine glow as the last light beams of the day fade along the jagged tips of these ancient giants. Aoraki, New Zealand.

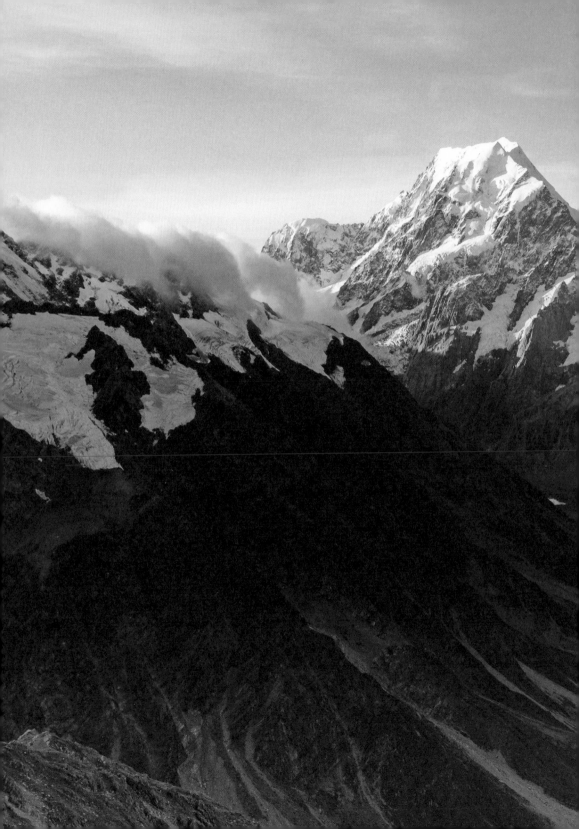

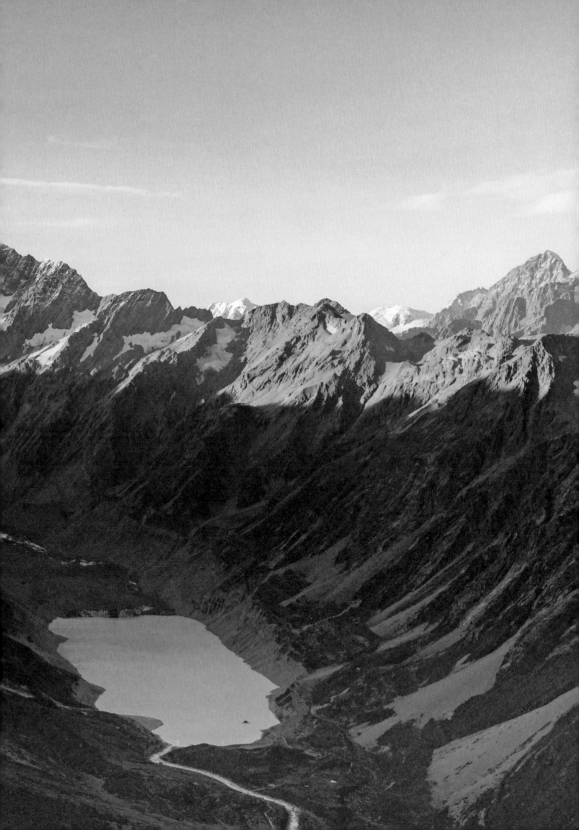

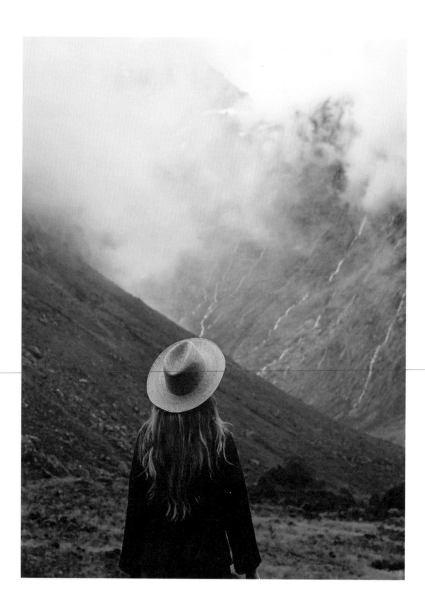

Above Clouds of mist fill the valley as hundreds of tiny waterfalls drop over the surrounding mountain walls. This is a landscape that truly comes alive after rain. Fiordland National Park, New Zealand. **Right** Majestic trees, some thousands of years old, make up these lush, green forests. Every element in this complex, intertwined, living and breathing ecosystem works in harmony to support a myriad of life. Olympic National Park, USA.

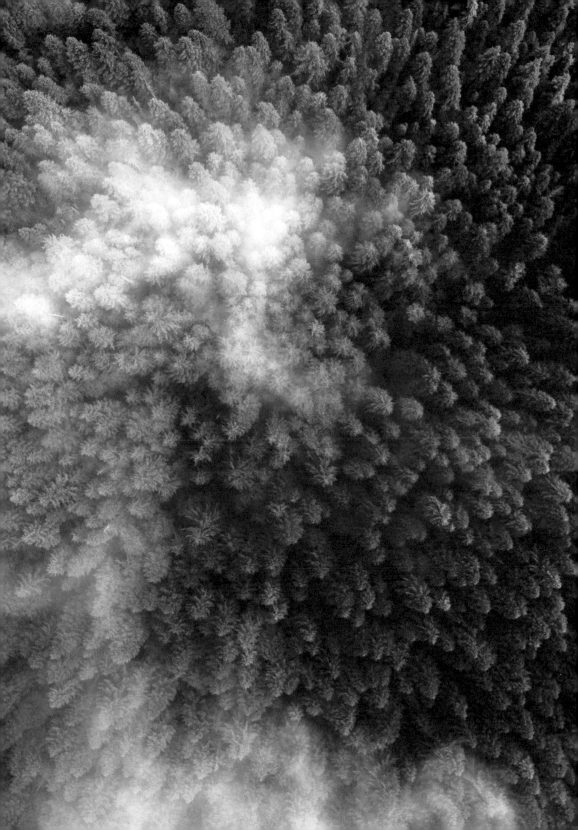

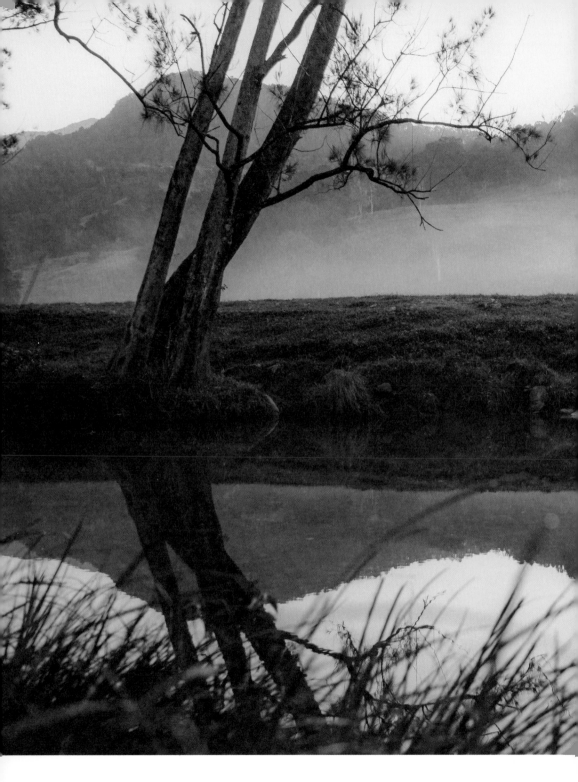

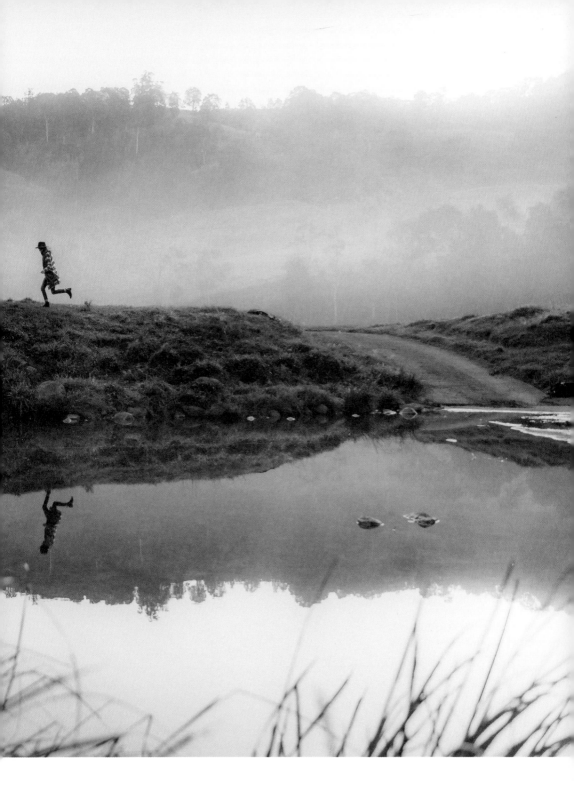

Let your spirit run free – you don't have to wander far from home to see our world in a new way. Scenic Rim, Australia.

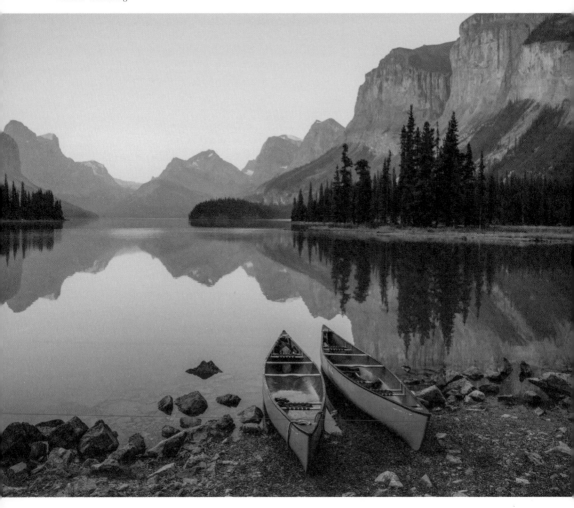

Let the mountains guide you to a sense of stillness and teach you the universal language of nature. The morning sun creates a soft glow on the turquoise waters of Spirit Island, Canada.

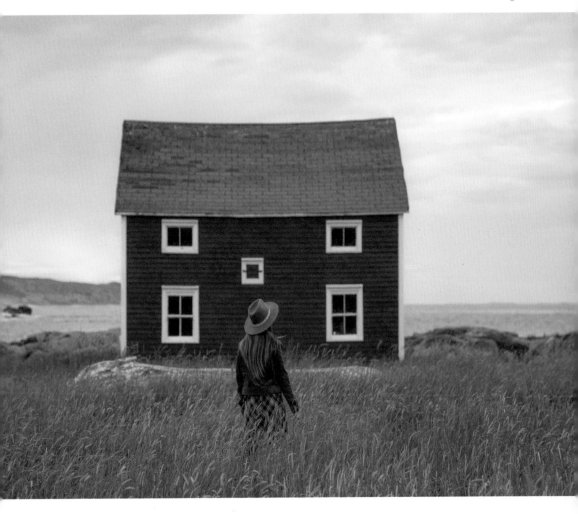

A little red cabin nestled between the sounds of the ocean and the touch of long grass; a place full of stories. Fogo Island, Canada.

*Earth has taught
me to keep an
open heart and
to always find
gratitude in the
smallest of things.*

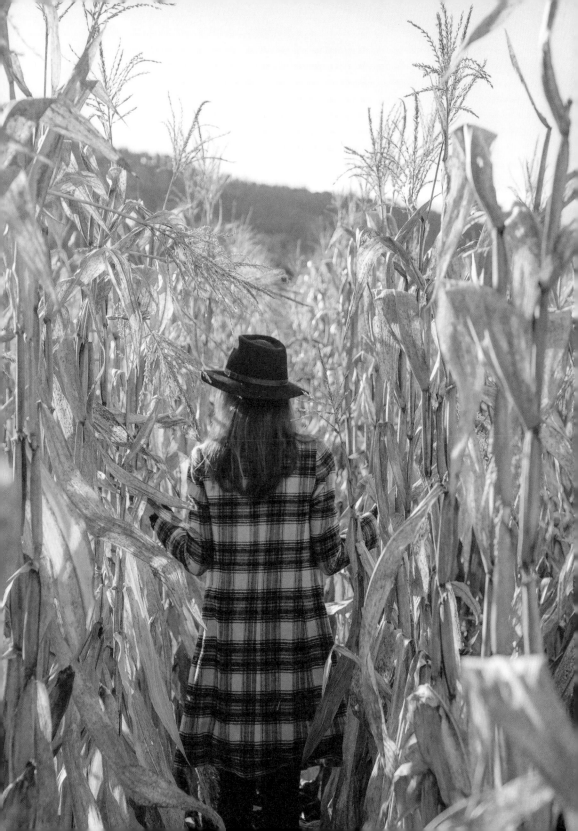

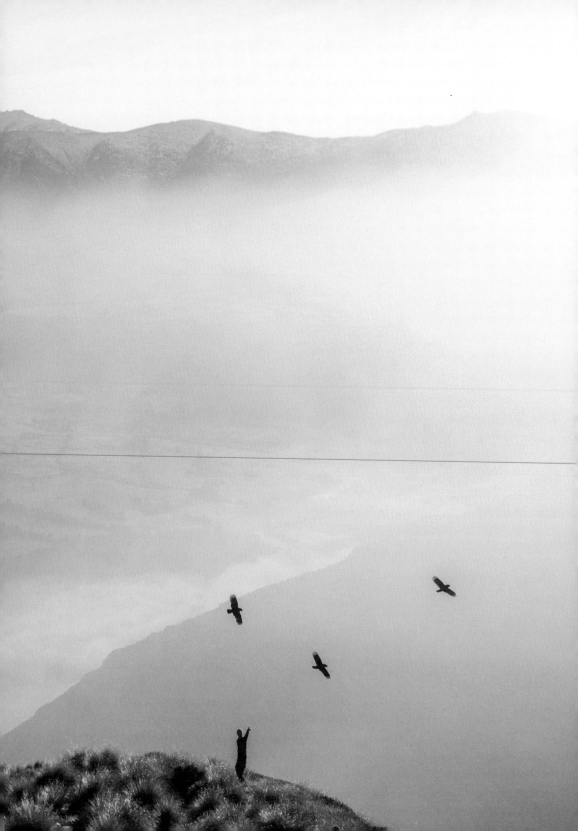

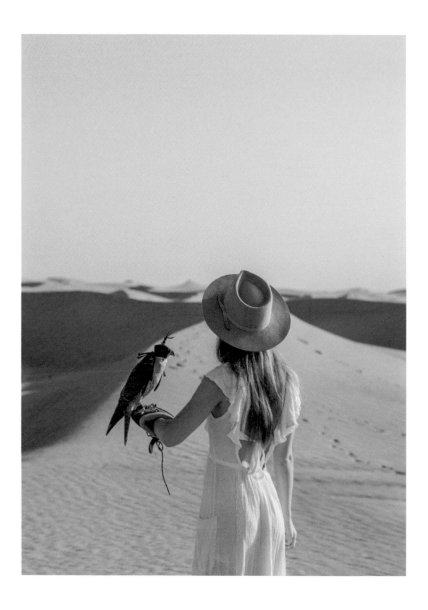

Left Golden haze as light overflows the mountain valleys. There is beauty found in the vastness of our wilderness. The Remarkables, New Zealand. **Above** Morning wanders exploring the desert of Dubai – connecting with nature in the harshest of landscapes. Al Qudra Desert, United Arab Emirates.

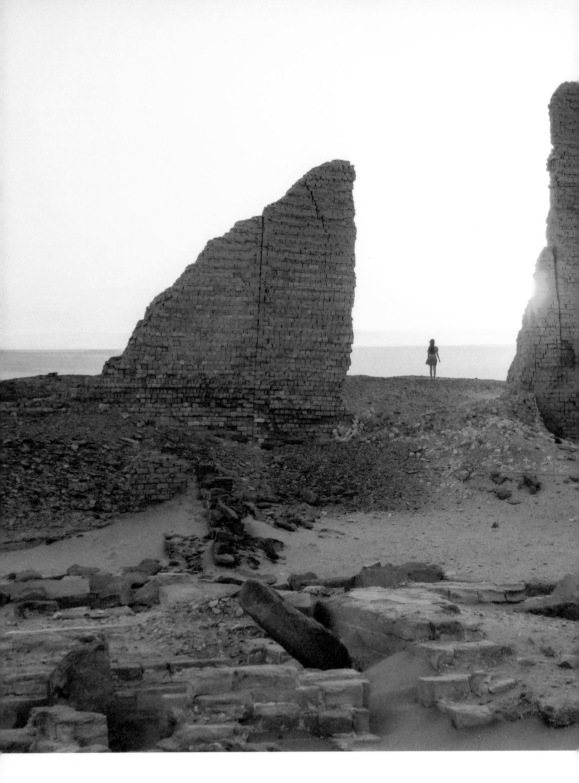

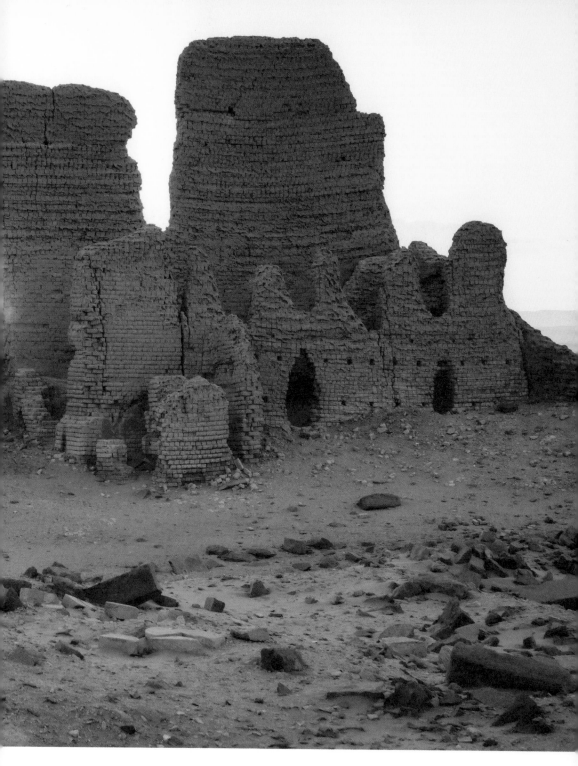

Light shining over ancient stones of the past. Imagine the world through the eyes of those who walked the path before us.
Faiyum, Egypt.

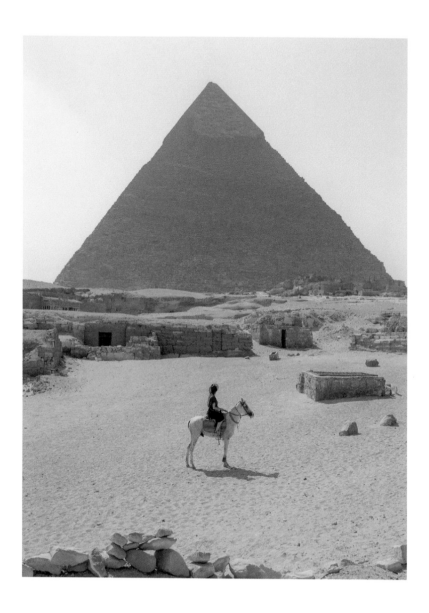

Left Live slowly and see the beauty in the little things – there is always a way to embrace our natural world **Above** Exploring the only one of the Seven Wonders of the Ancient World to still exist. A sense of nostalgia surrounds these lost worlds of the past. Great Pyramid of Giza, Egypt. **Overleaf** The rustic boathouse of Lake Braies, nestled within the heart of the Dolomites. Pragser Wildsee, Italy.

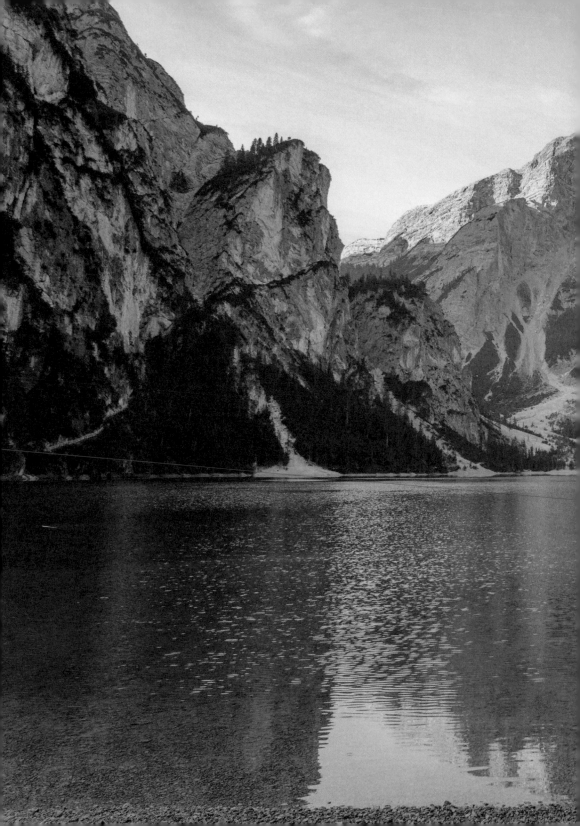

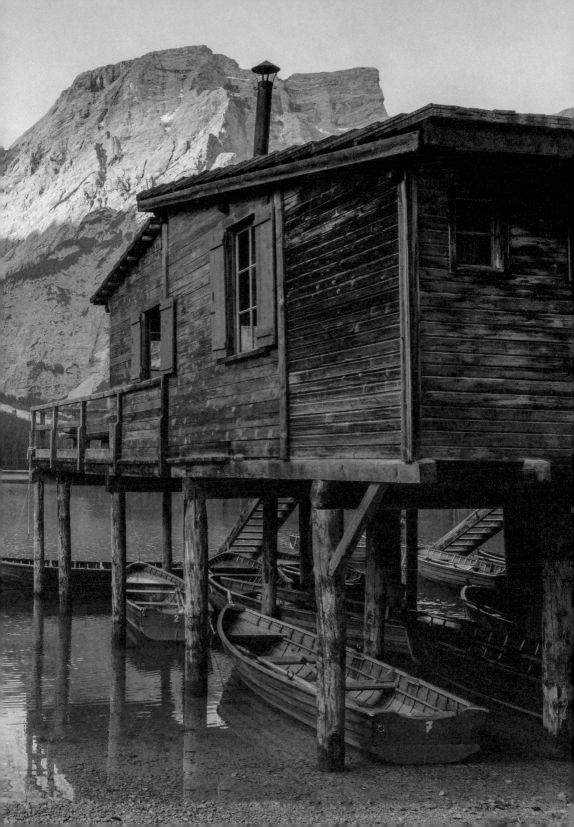

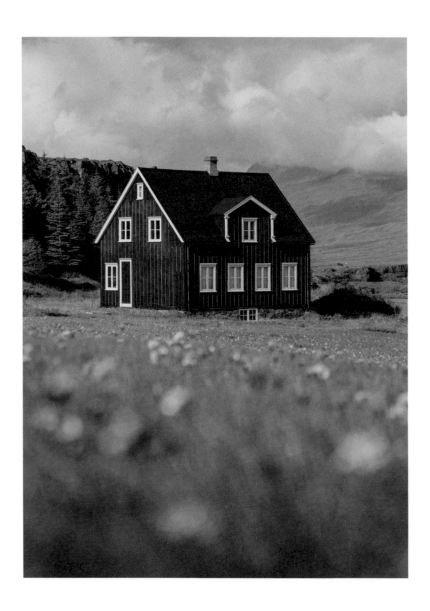

Left Search for the mysteries hidden throughout our beautiful planet **Above** The further I travel the more I've come to look for and truly appreciate the concept of home. Traditional Icelandic house in Djúpivogur, Iceland.

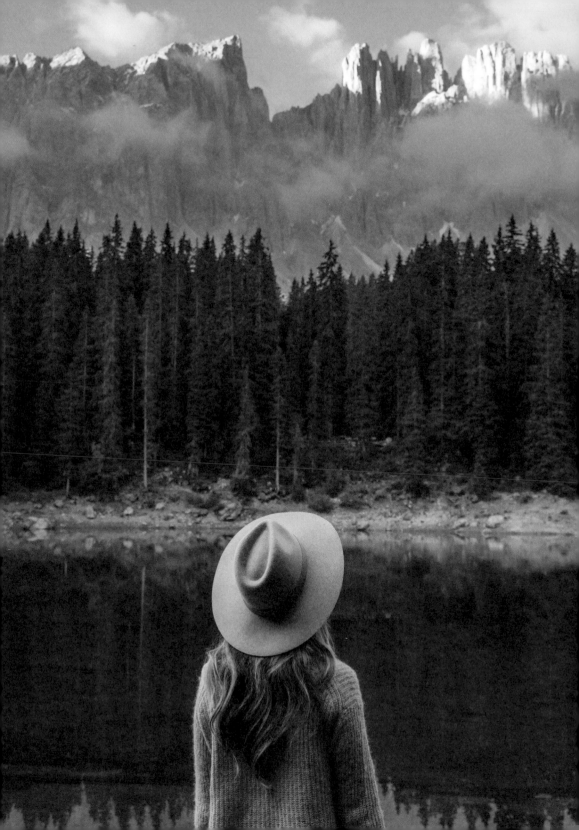

These landscapes fill my heart, yet leave me feeling vulnerable and at awe with our existence.

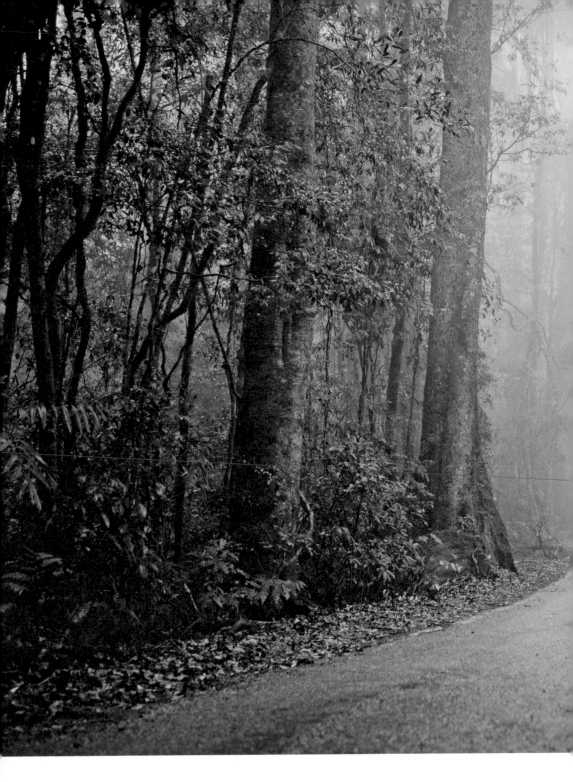

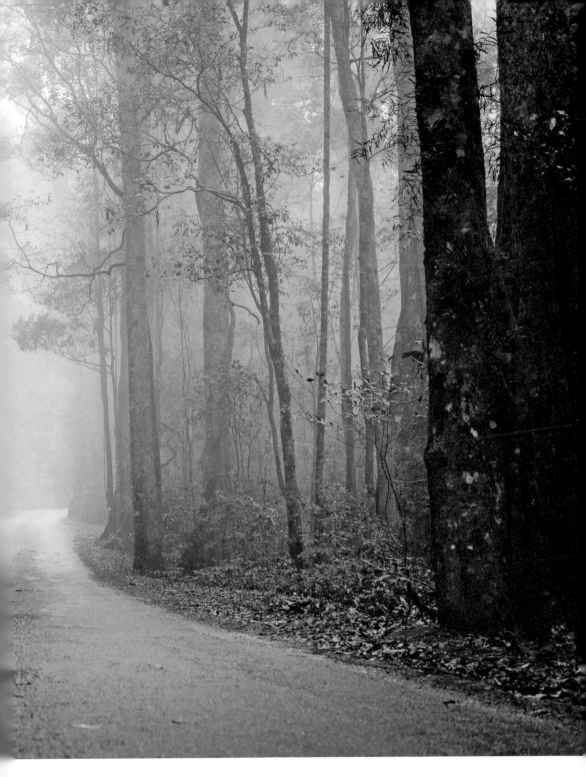

Transported to another time, these mystical rainforests are the remnants of the ancient Gondwanan forests that once covered the Australian continent – a glimpse into how our natural world once was. Lamington National Park, Australia.

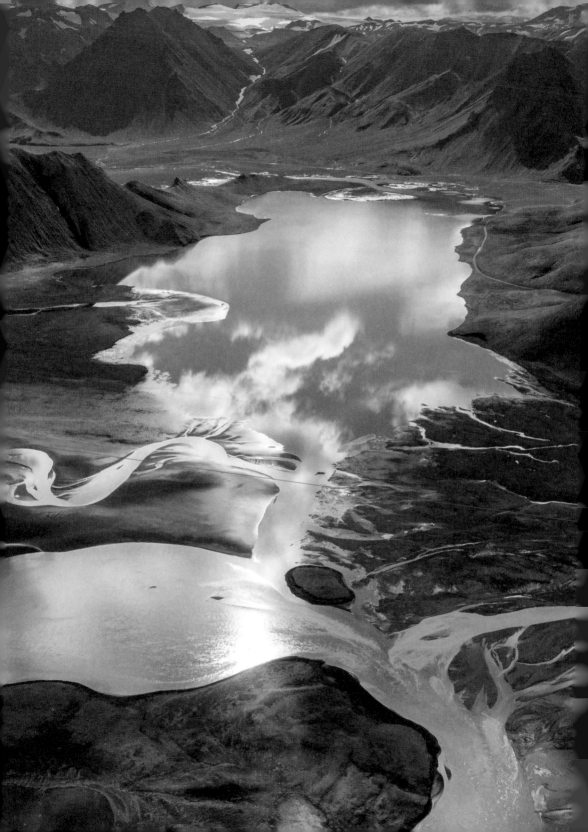

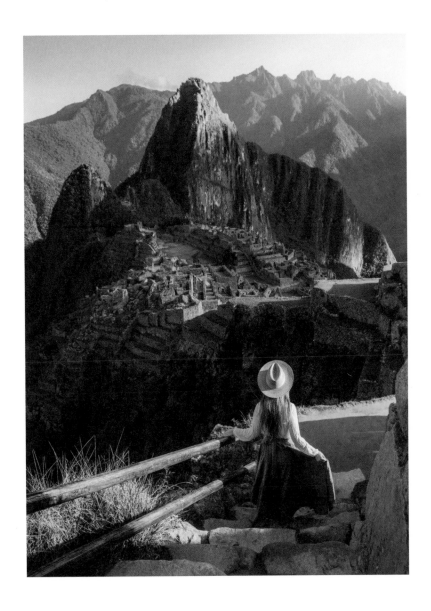

Left Volcanoes surrounded by bright blue lakes and interweaving riverbeds, forming one of our planet's many otherworldly landscapes. Central Highlands, Iceland. **Above** Hidden deep in the Andes Mountains lies the ancient mystical ruins of Machu Picchu, Peru

Wander freely within the wild to discover the ever-changing beauty of nature.

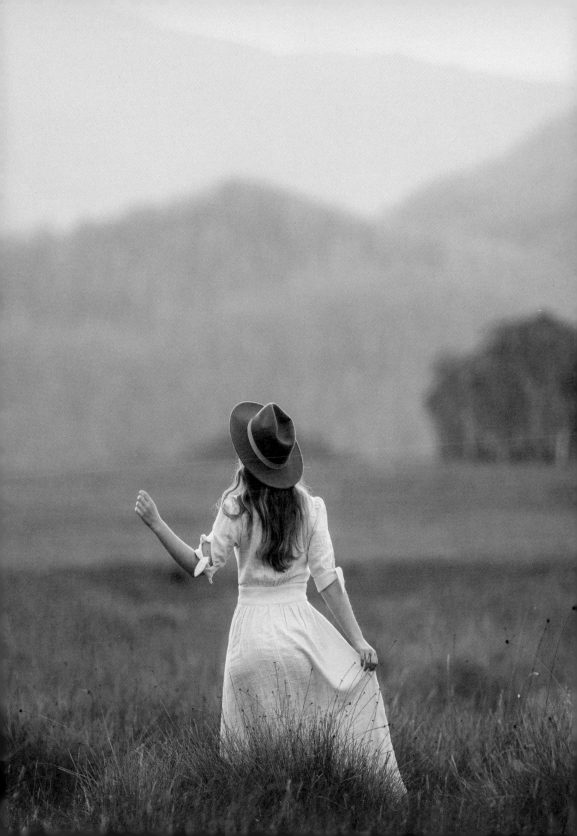

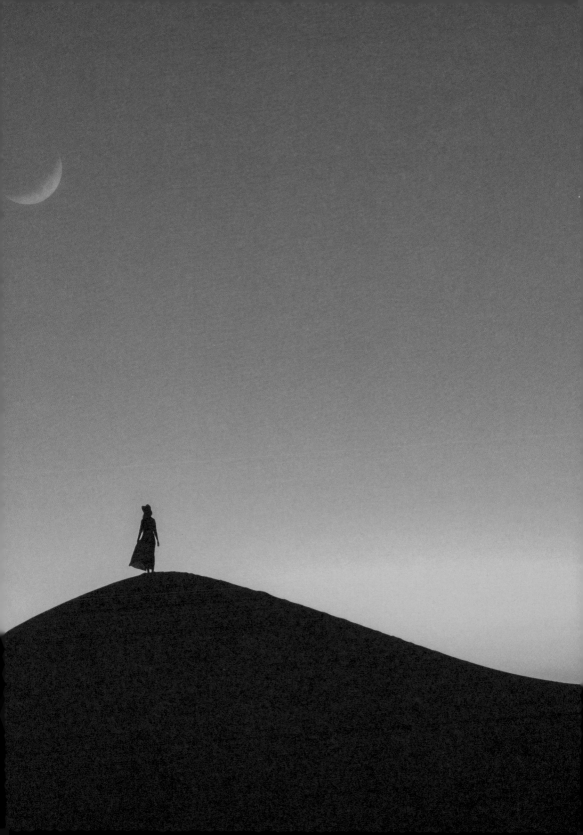

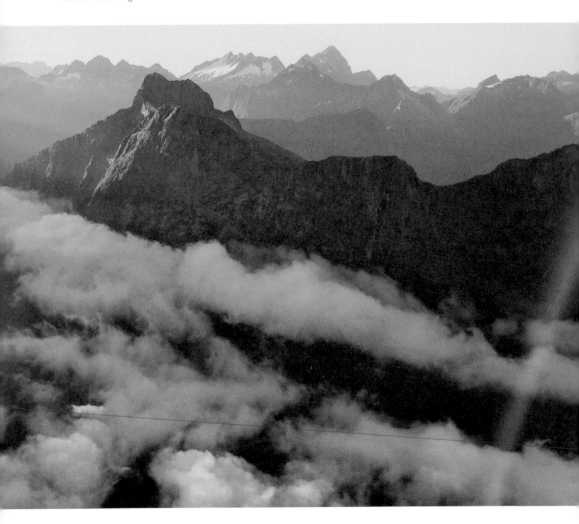

Previous Look up to the infinite universe and wonder at how perfectly the planet's biosphere supports life for us all. We are all made of stardust, a tiny piece of this beautifully vast universe. Rub' al Khali, United Arab Emirates. **Above** Our mountain landscapes come alive with soft layers of ever-changing clouds, fog and light drifting between the peaks and valleys. Fiordland National Park, New Zealand.

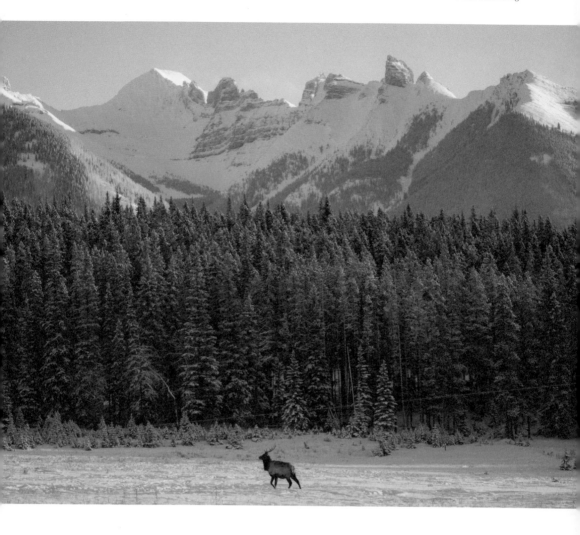

A lone wild elk wandering within the cold of winter. Wild landscapes like this are places that inspire me to wander deeper into their beauty. Banff National Park, Canada.

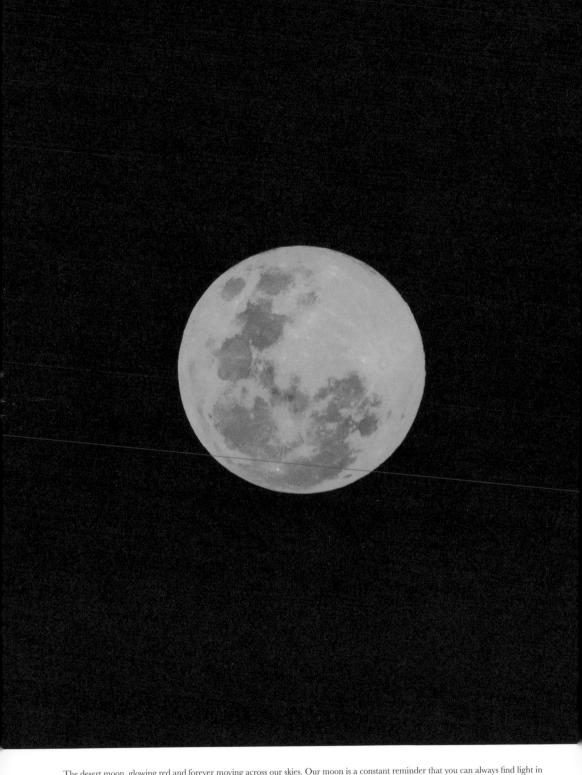

The desert moon, glowing red and forever moving across our skies. Our moon is a constant reminder that you can always find light in the darkness.

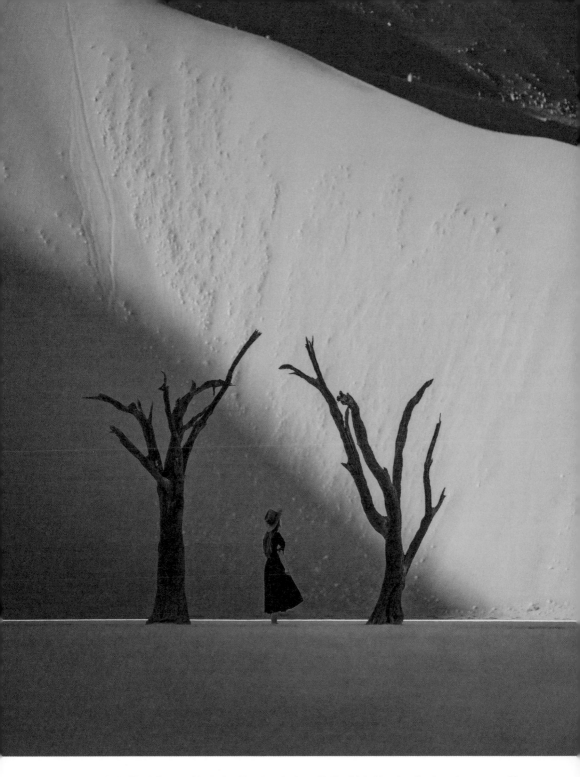

Skeleton trees lost in the Namib Desert, said to be the oldest desert in the world. Namibia holds a place deep in my heart, a powerful landscape my mind always wanders back to. Deadvlei, Namibia.

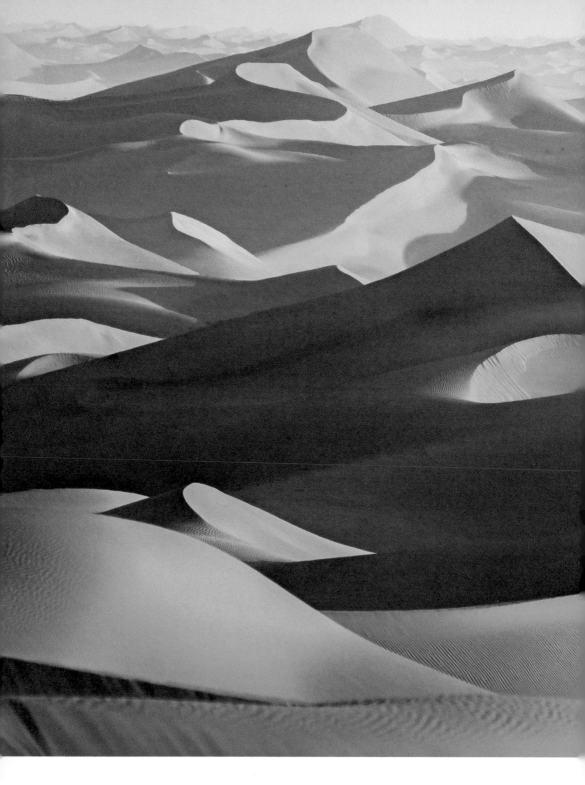

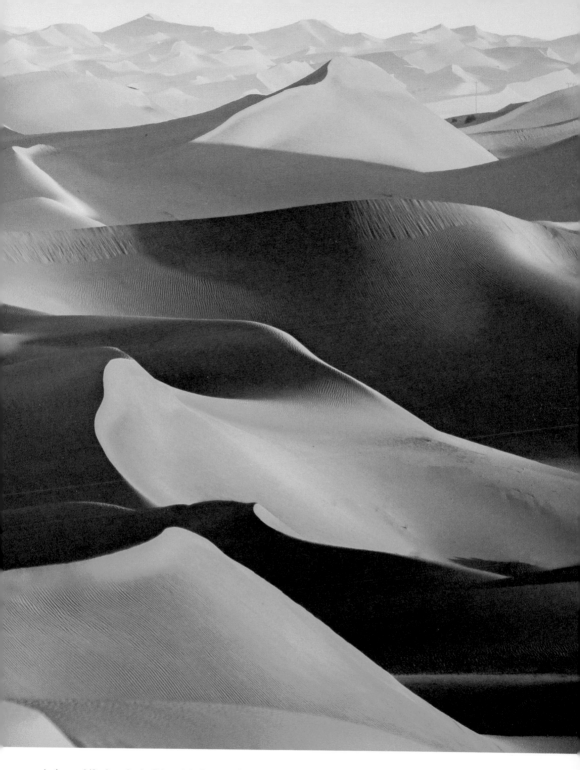

As the sun drifts along the sky, light and shadows transform this sweeping untouched and seemingly endless landscape. The Rub' al Khali desert, United Arab Emirates.

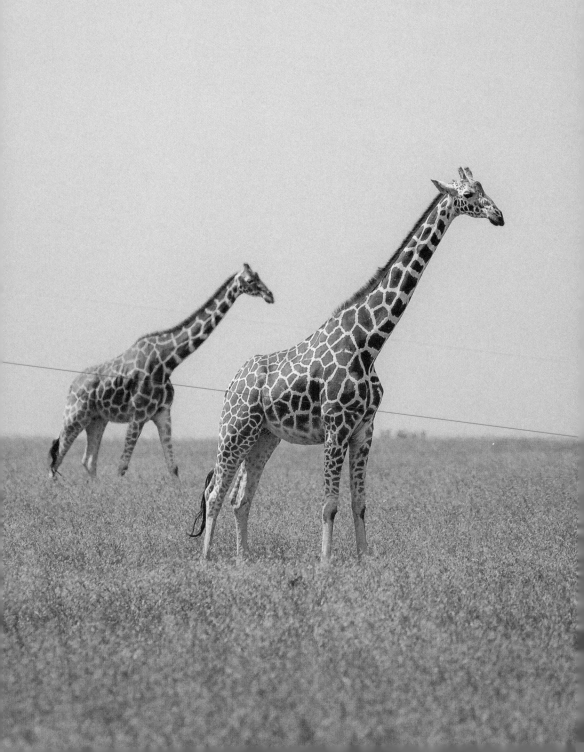

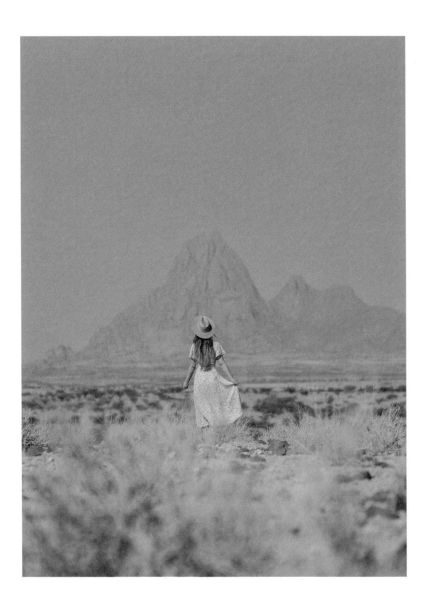

Left A pair of giraffes wandering through the open golden grasslands of Maasai Mara, Kenya **Above** Seek the road less travelled. Wandering through the dry grasses and arid desert landscapes of Spitzkoppe, Namibia. **Overleaf** Golden light glistening through diamond-shaped ice that has drifted ashore. Starting their journey at Breidamerkurjokull Glacier years ago, these natural ice sculptures eventually make their way out to the Atlantic Ocean. Diamond Beach, Iceland.

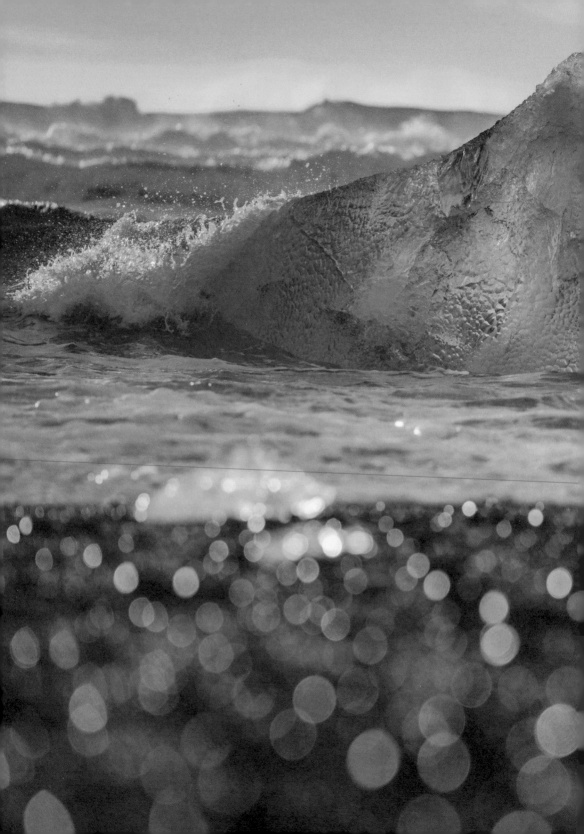

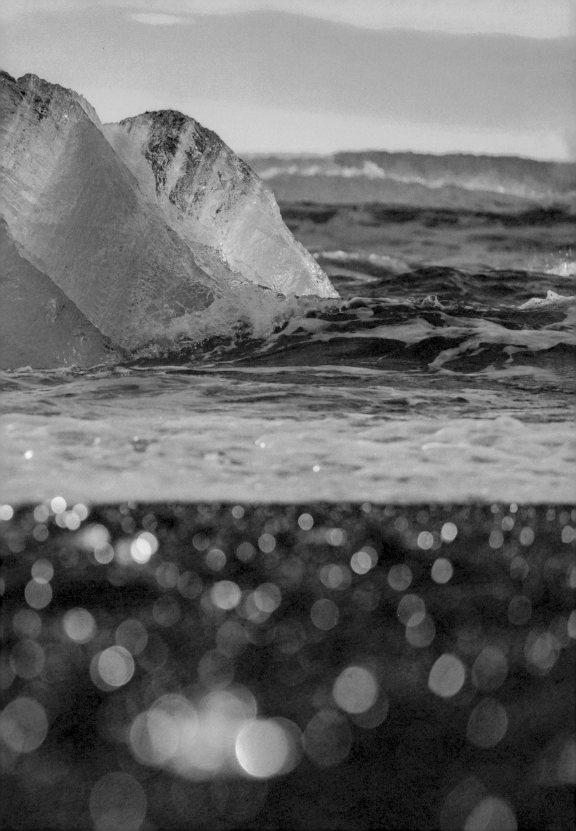

We all belong to
the same home —
we share the same
sky, the same sun
and the same moon.

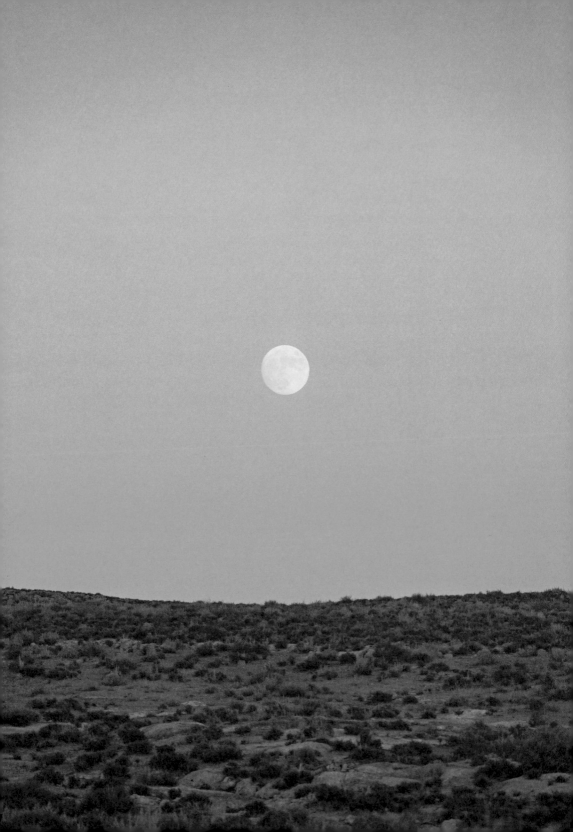

Always searching for ways to learn from and live in harmony with nature. These simple choices let us rediscover the natural world around us.

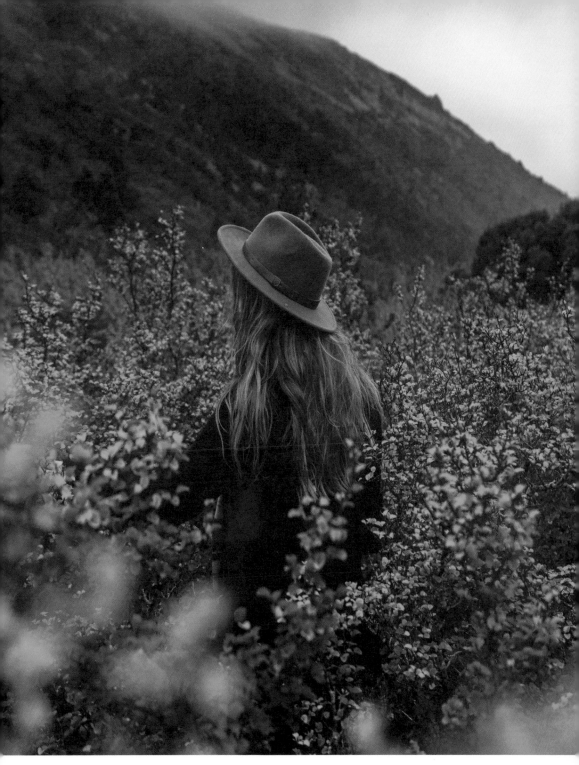

Autumn in the Tasmanian Highlands, when the mountains explode into a sea of yellows and oranges transforming the entire valley. Cradle Mountain, Australia. **Overleaf** Sunlight dappling between the trees by a snow-covered cabin in the midst of the Arctic Circle. Lapland, Finland.

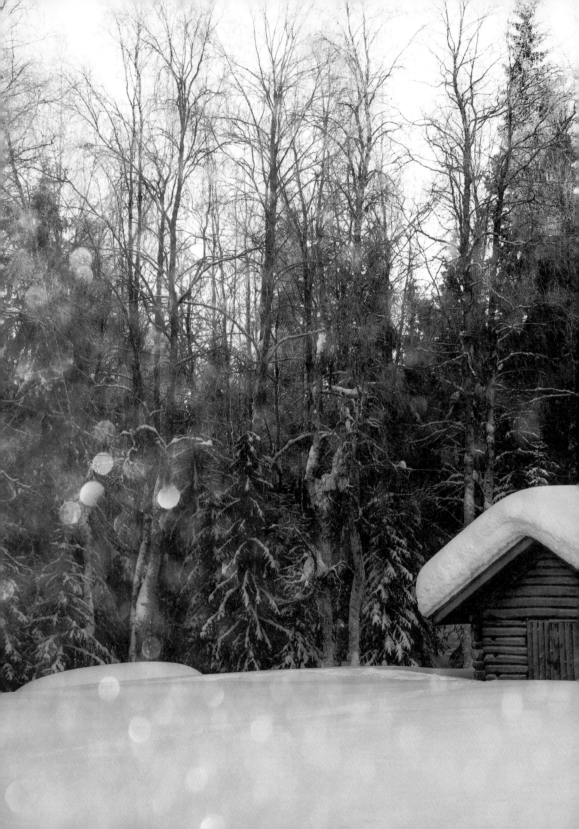

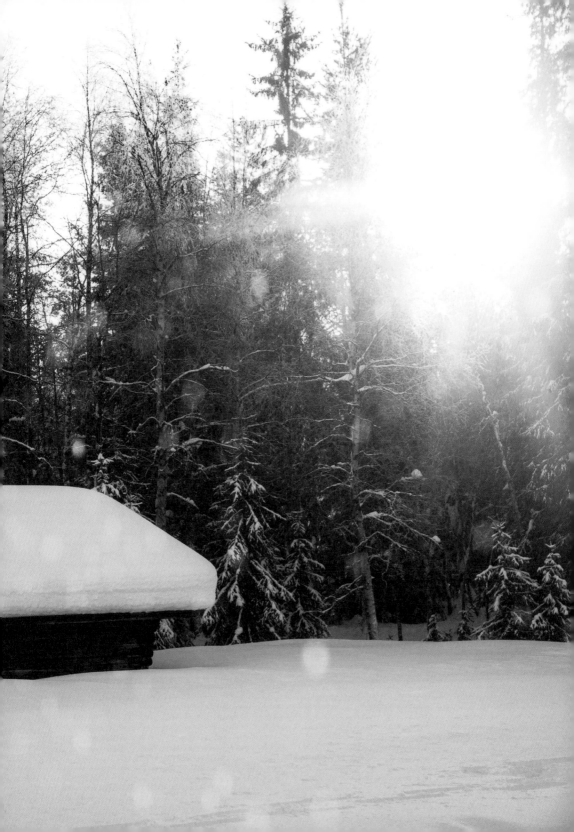

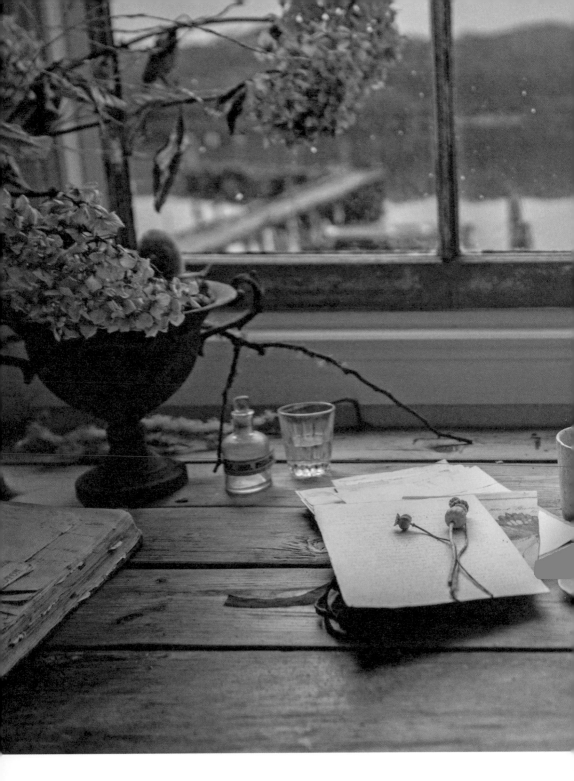

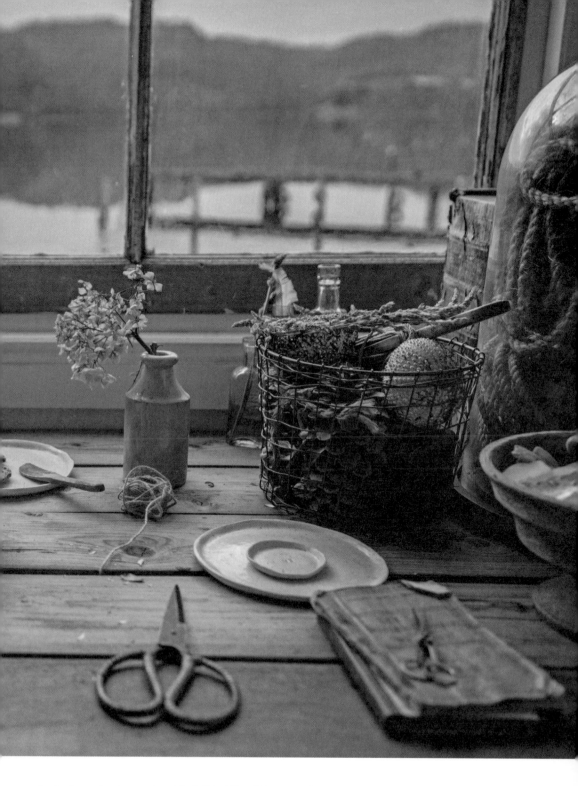

A quiet place to sit and contemplate while the light shifts and changes over the water and hills in the distance. Strahan, Australia.

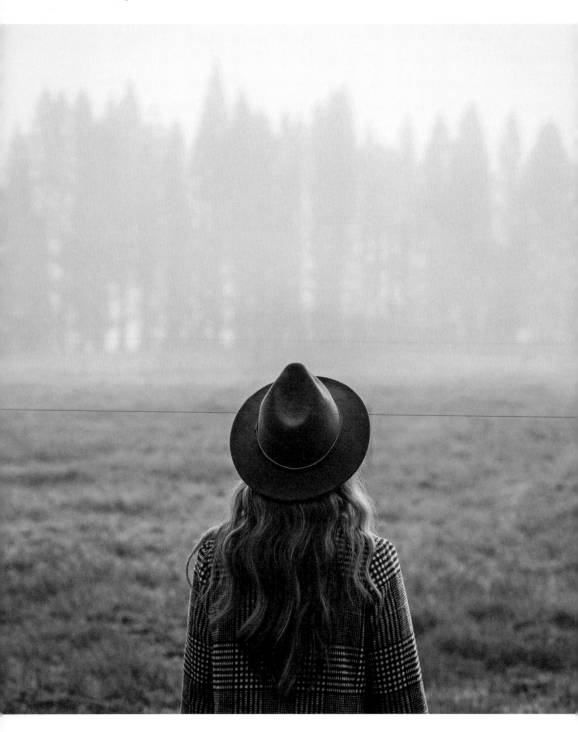

Dreamy morning mist encompassing an entire valley. Southern Alps, New Zealand.

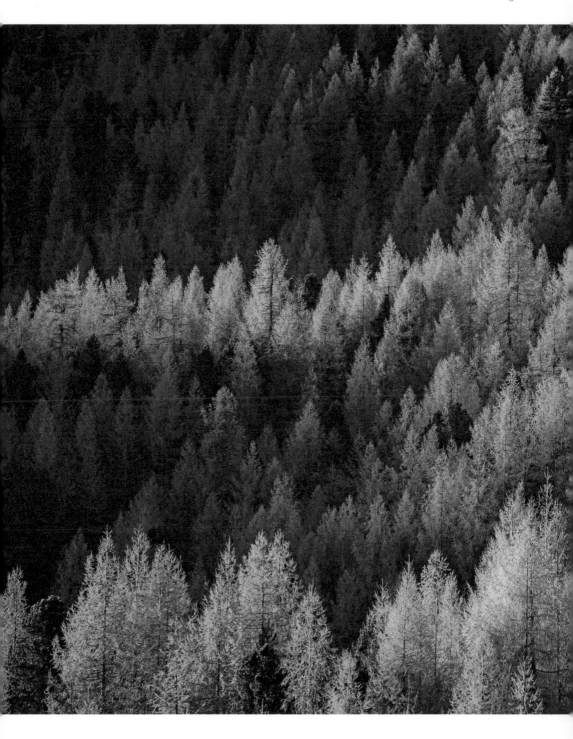

Seemingly endless alpine trees in vibrant autumn colours. The Dolomites, Italy.

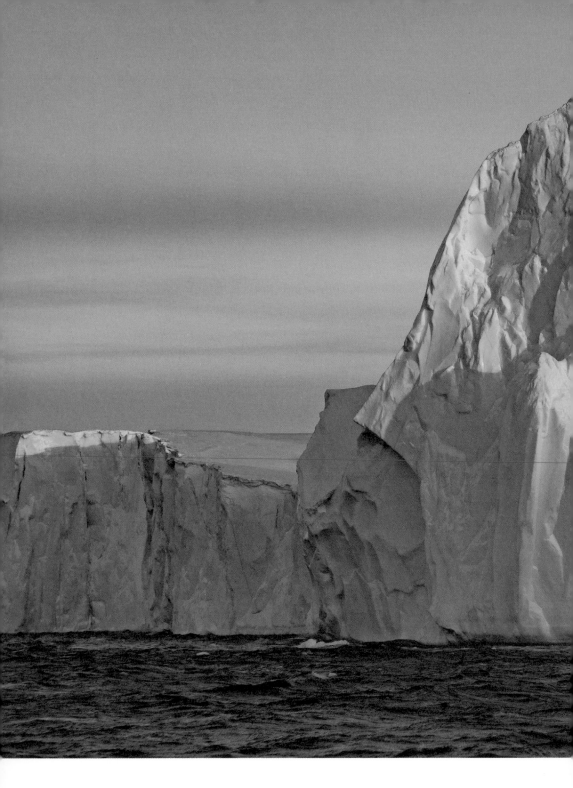

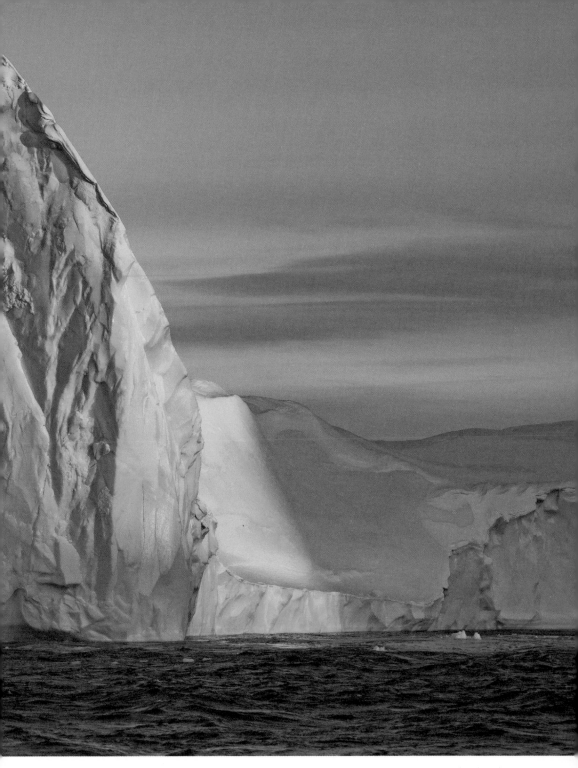

Glowing light casts vibrant colours on these ancient arctic mountains of ice. Once frozen in time, these icebergs now float throughout the open sea, constantly transforming and creating a precious moment in time before they melt and disappear into the Atlantic Ocean. Ilulissat, Greenland.

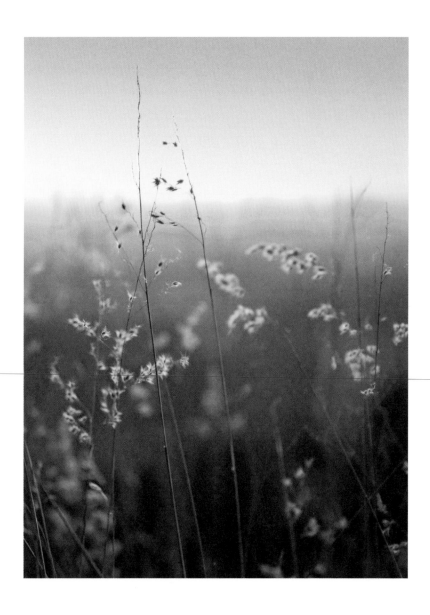

Above Finding a sense of calm watching the golden light through the grass. Scenic Rim, Australia. **Right** A moment to reflect by the glass-like turquoise water, peacefully mirroring the surrounding mountain peaks on the horizon. Lake Braies, Italy.

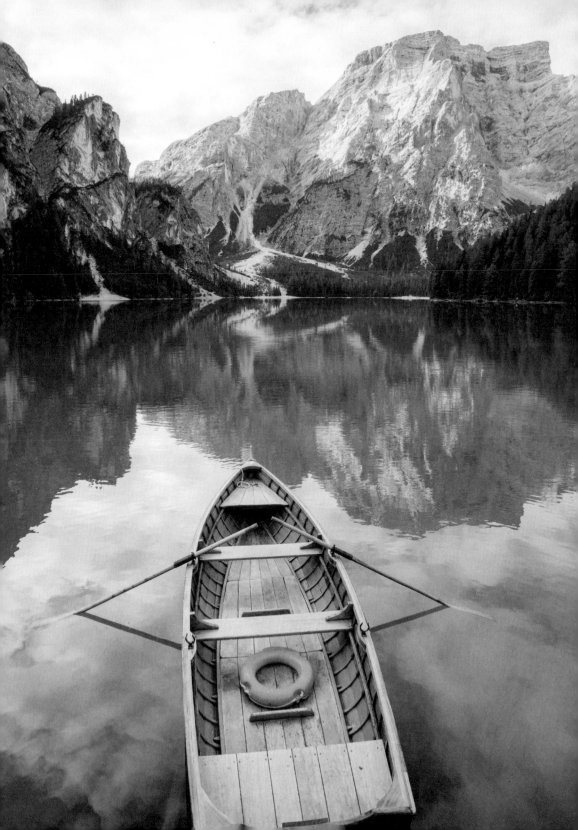

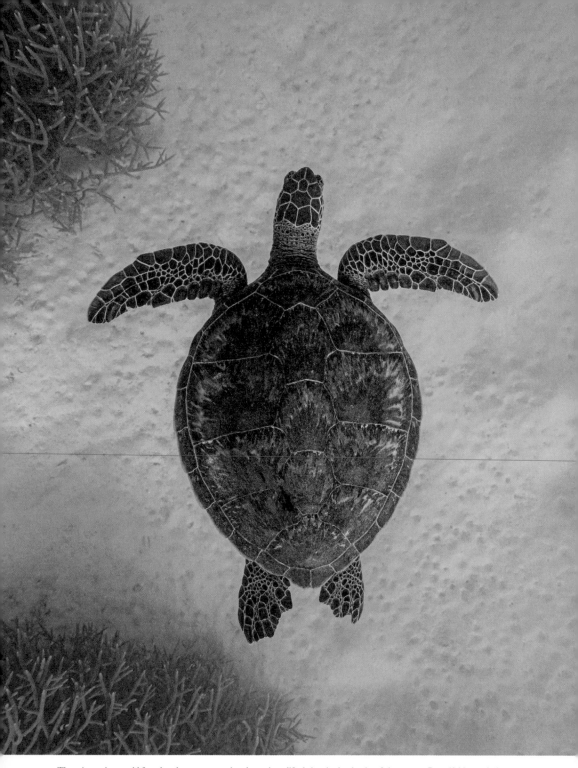

There is another world found underwater – a quiet place where life thrives in the depths of the oceans. Beautiful layered plate coral, endless colonies of fish and green sea turtles are just a glimpse of the abundance of life found here. The Great Barrier Reef, Australia.

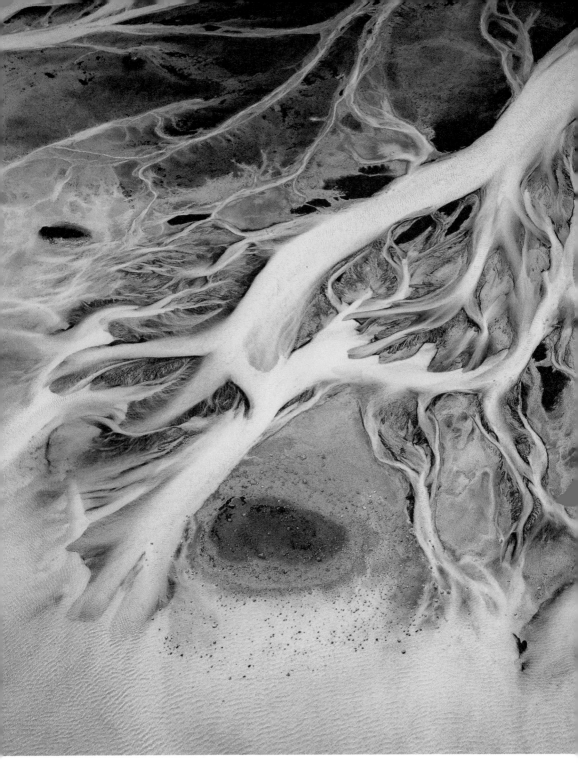

Melting glaciers forming intertwined streams as the water runs towards the ocean. Our planet's water is circulating and forever in motion, evaporating from the ocean and transpiring from our forests to form clouds and rain that comes back down to our land again. Langjökull, Iceland.

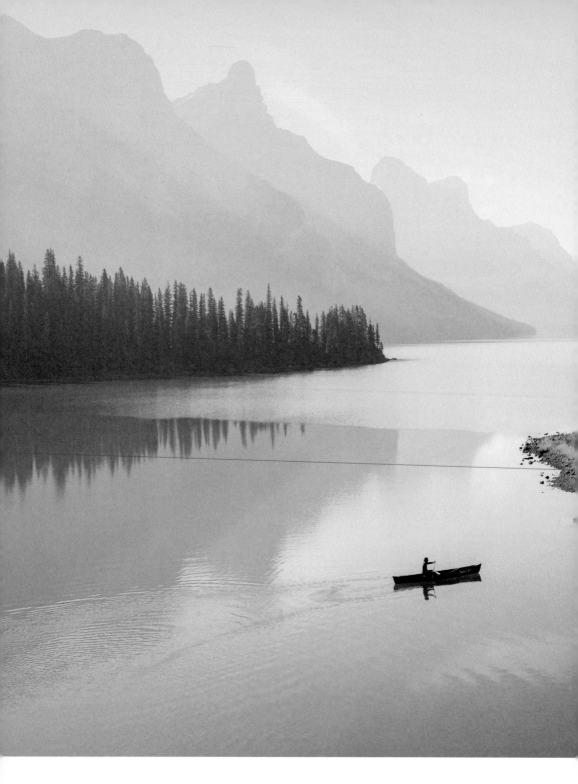

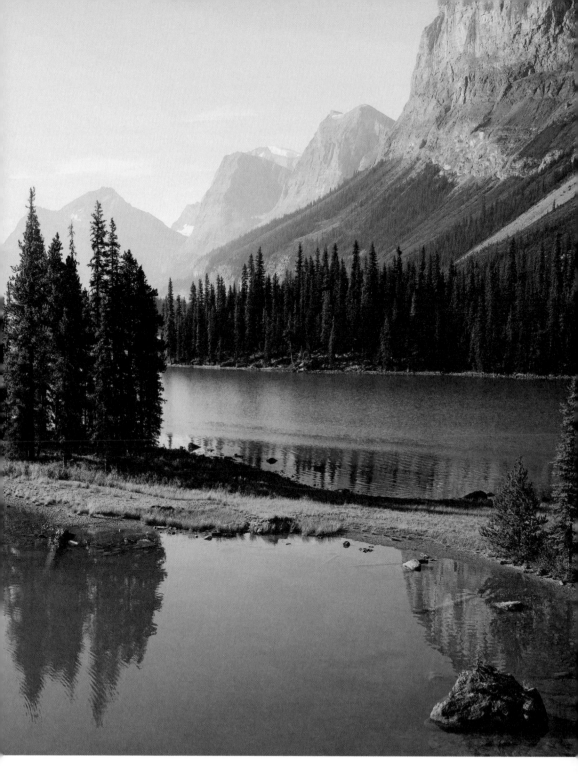

Surrounded by ancient glaciers and floating through emerald-blue water amongst the majestic mountains, lush green forests and beautiful blue rivers and lakes. Maligne Lake, Canada.

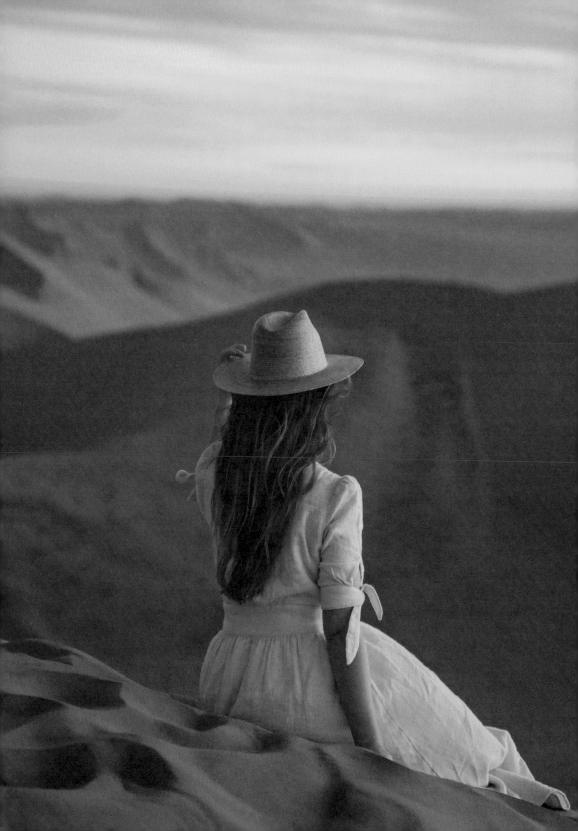

A fleeting moment in time where, just for a second, I became lost in a sense of wonder.

There is magic to be found in every corner of our planet.

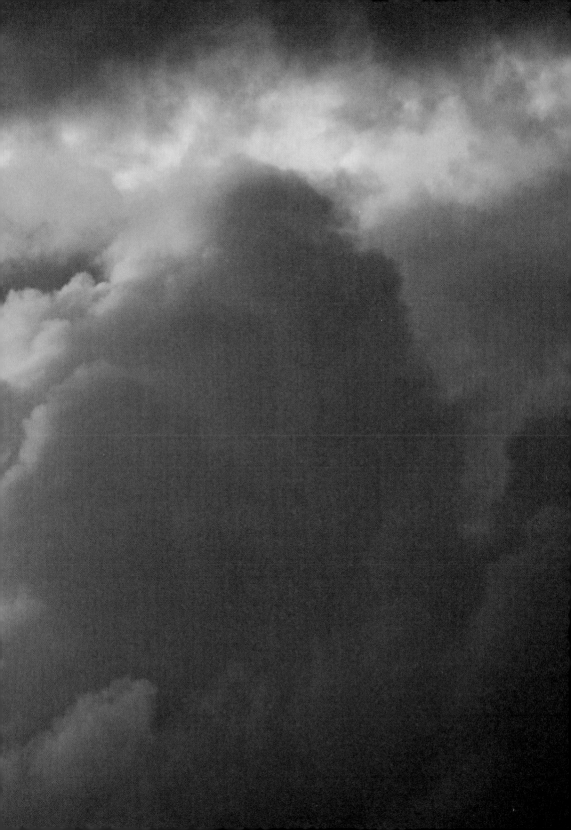

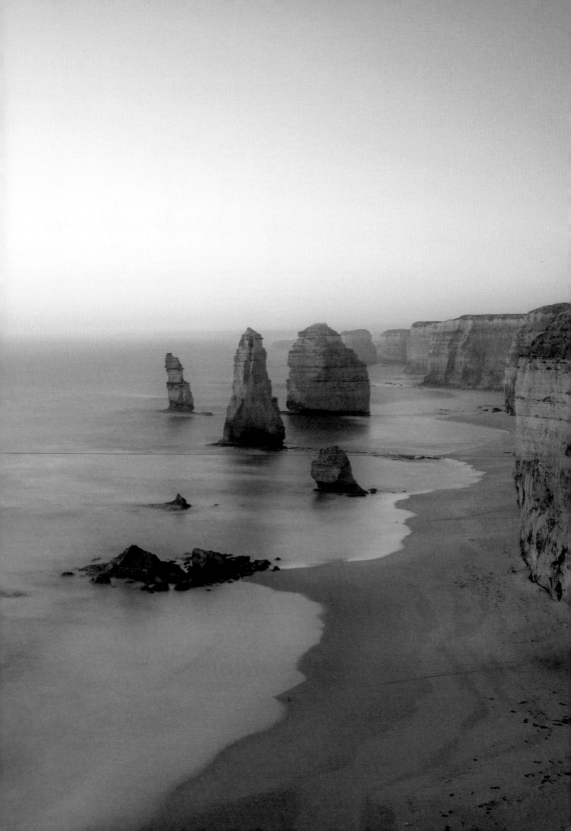

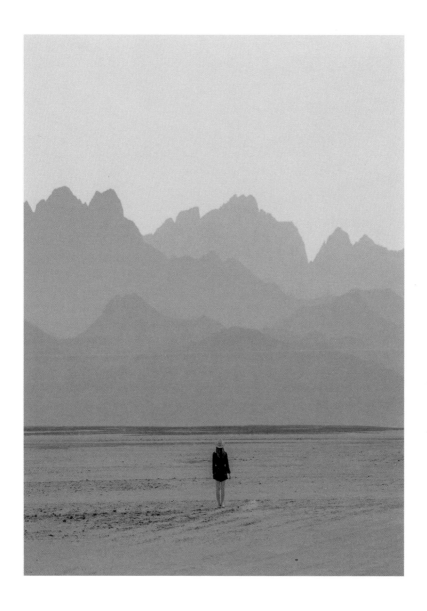

Left Shaped by the ocean and eroded by the wind, the uncontrollable power of nature is evident in these ancient limestone formations. The Twelve Apostles, Australia. **Above** Wandering through the barren plains, this vast landscape drastically transforms into unimaginable layers of mountain ranges. Red Sea Mountains, Egypt. **Overleaf** A herd of over ten thousand African oryx running across the savannah plains; a rare sighting after much needed rain blessed this dry and harsh landscape. Maltahöhe, Namibia.

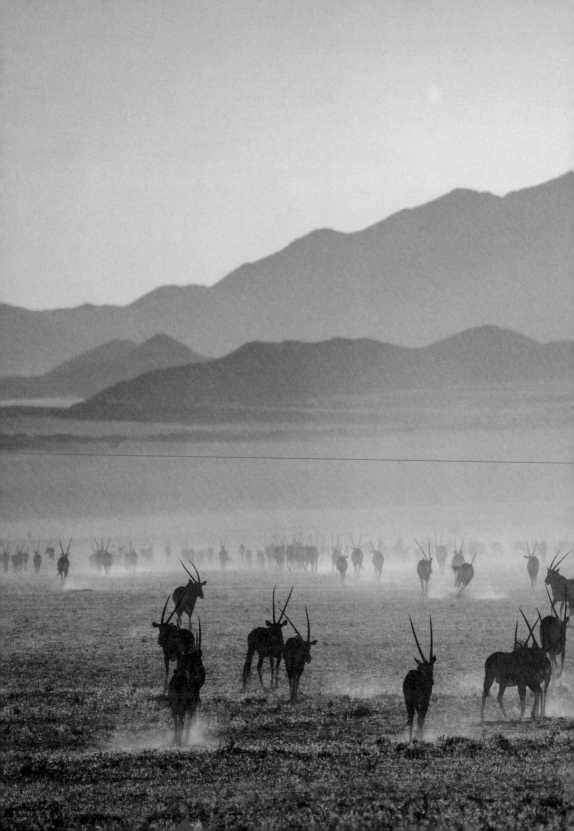

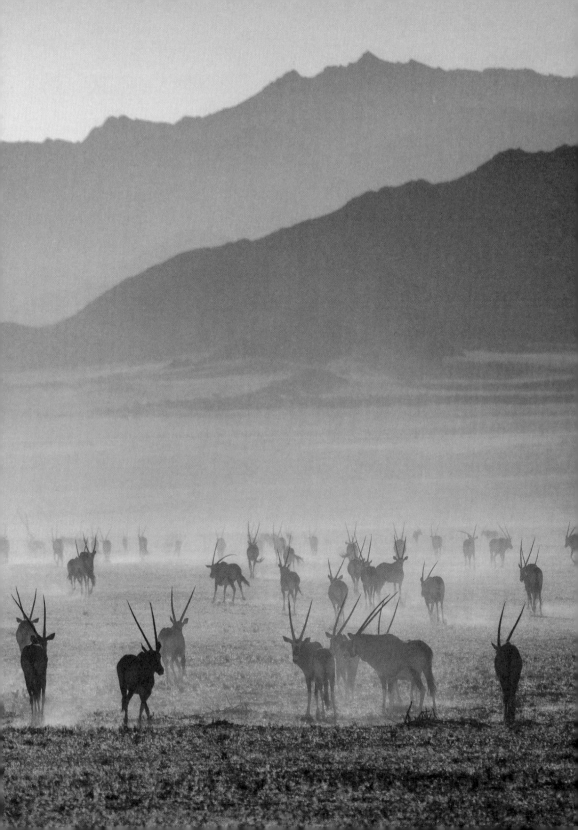

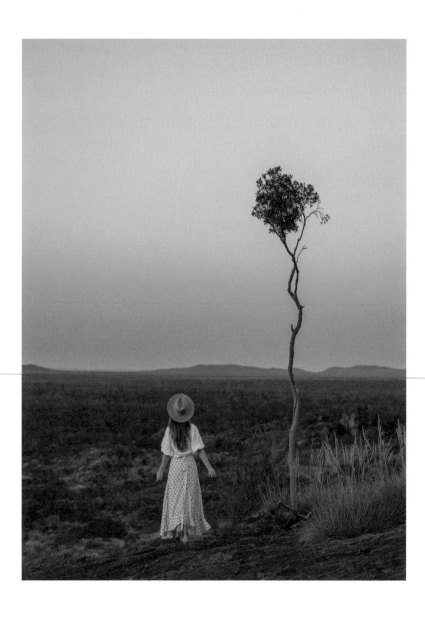

Above As the sun goes down, the entire escarpment begins to glow with deep oranges and reds, slowly giving way to dusk and eventually disappearing into darkness. Nawurlandja Lookout, Australia. **Right** Look closely to notice the ubiquitous patterns and textures found in our natural world. The colours and shapes carved deep into our Earth's surface remind me to notice the infinite complexities found in nature.

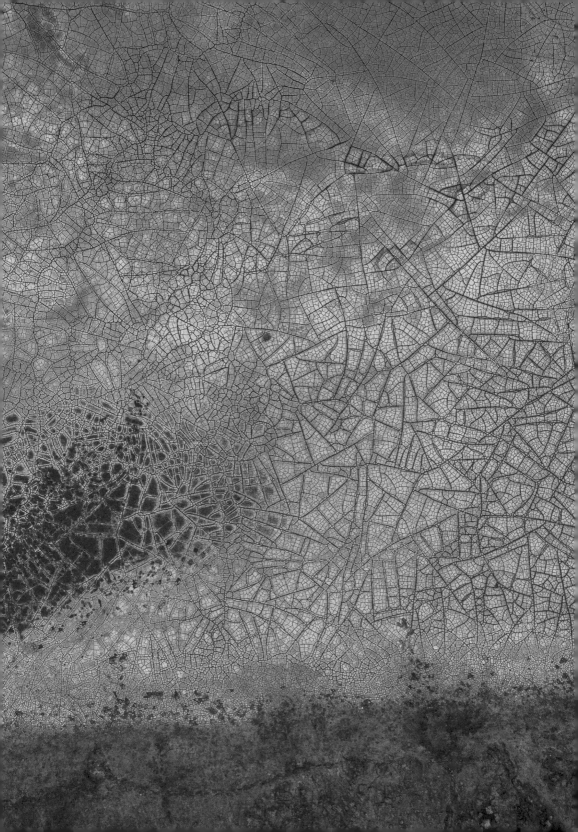

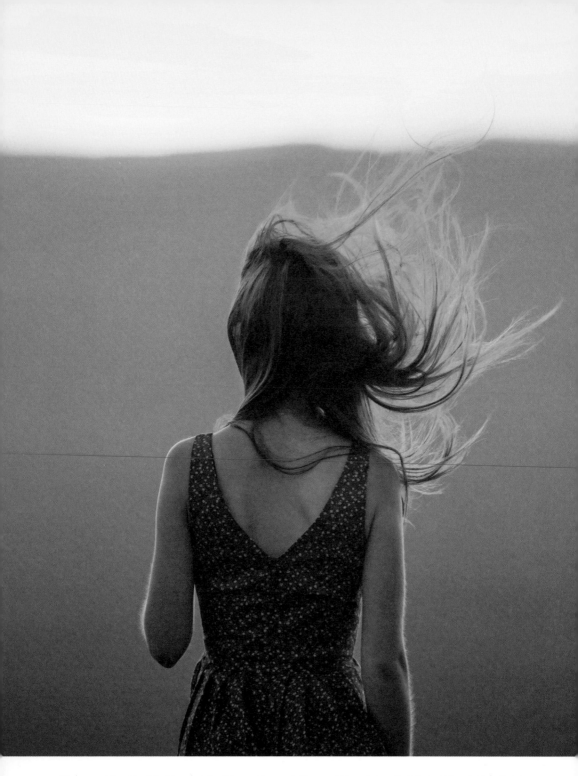

Windswept while golden light fills my mind and heart with warmth. Retreat within to find gratitude in the tiniest of things. Dusk in Grampians National Park (Gariwerd), Australia.

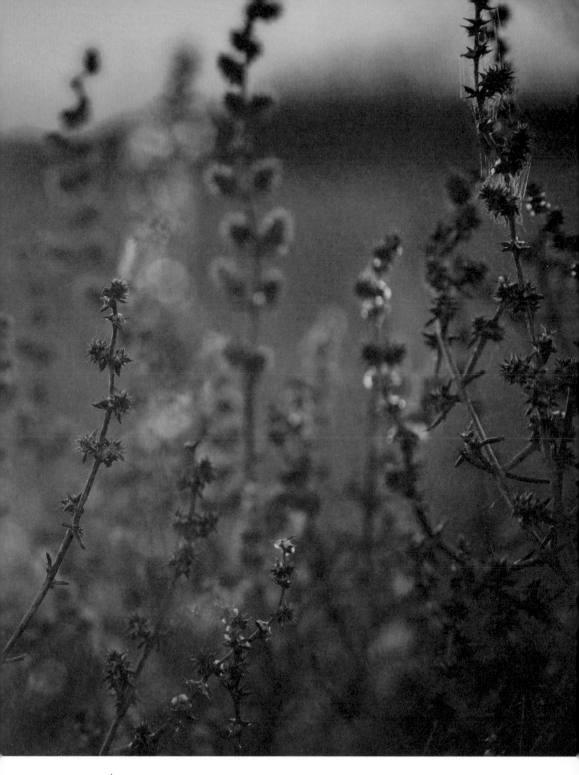

Notice the light and the way it moves, creating ever-changing shadows. Notice the way it envelops its surroundings, leaving all edges with a touch of softness. Broome, Western Australia.

Be wild at heart and explore the raw and unpredictable ways of nature.

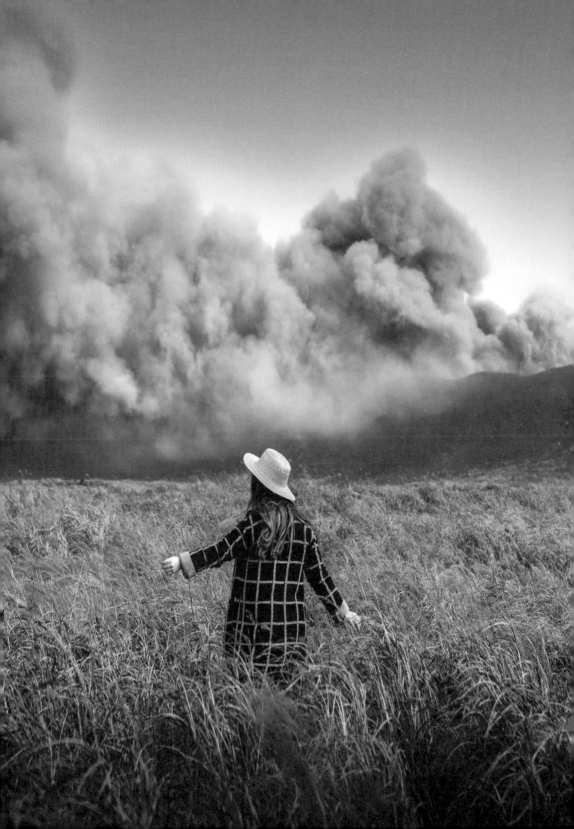

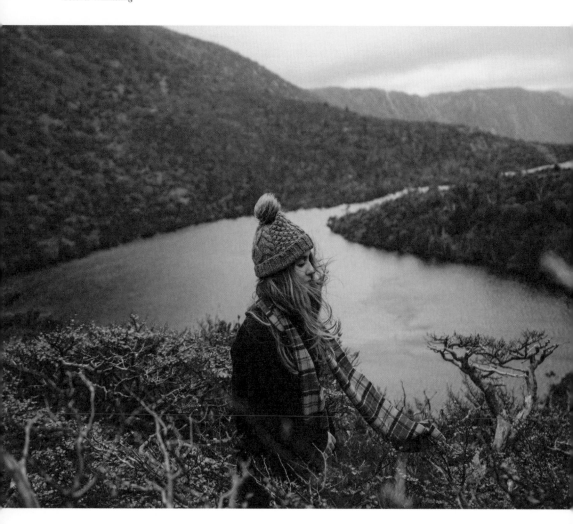

Rich autumn colours make the unique Tasmanian forests come to life. The impermanency found within nature allows us to truly appreciate every moment and season. Lake Hanson, Australia.

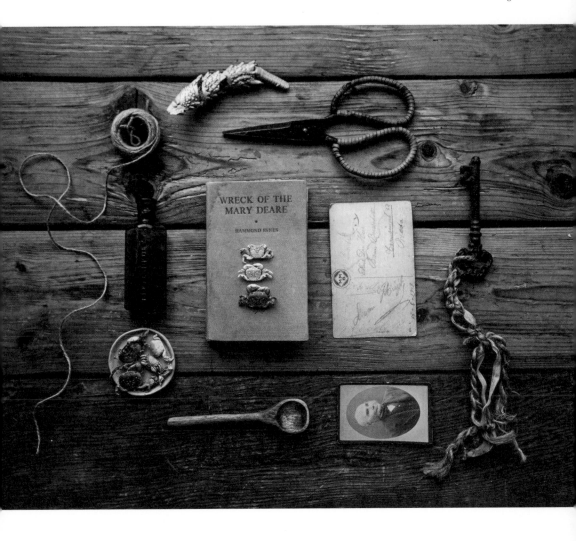

Above Our natural environment encompasses all living things, breathing and existing as one. By bringing nature inside we are able to strengthen our connection to our surrounding environments. **Overleaf** The magical time of day between darkness and daylight, completely surrounded by mountains in every direction. There is something special about being awake and wandering in nature in the pre-sunrise glow. Spirit Island, Canada.

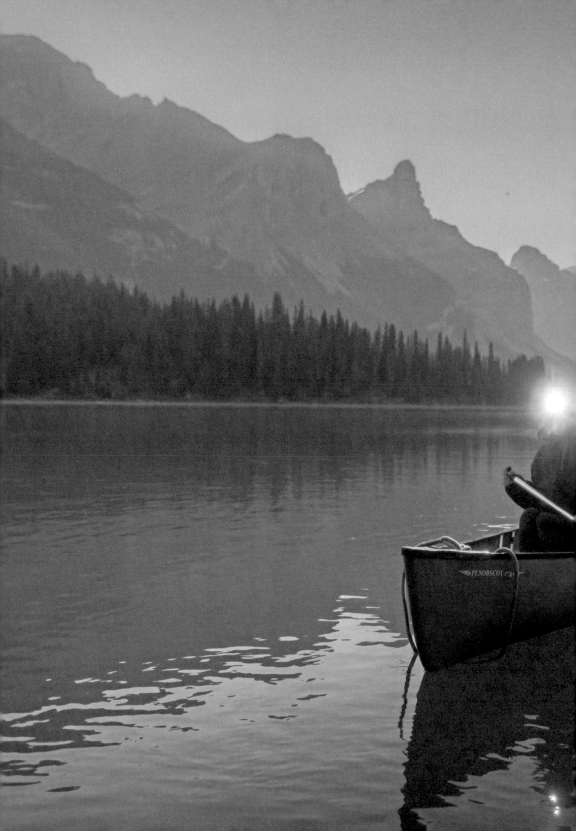

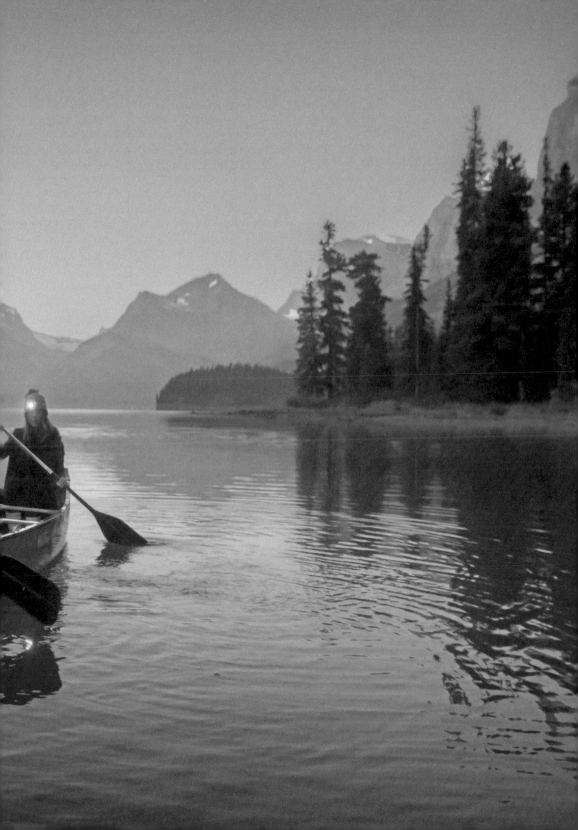

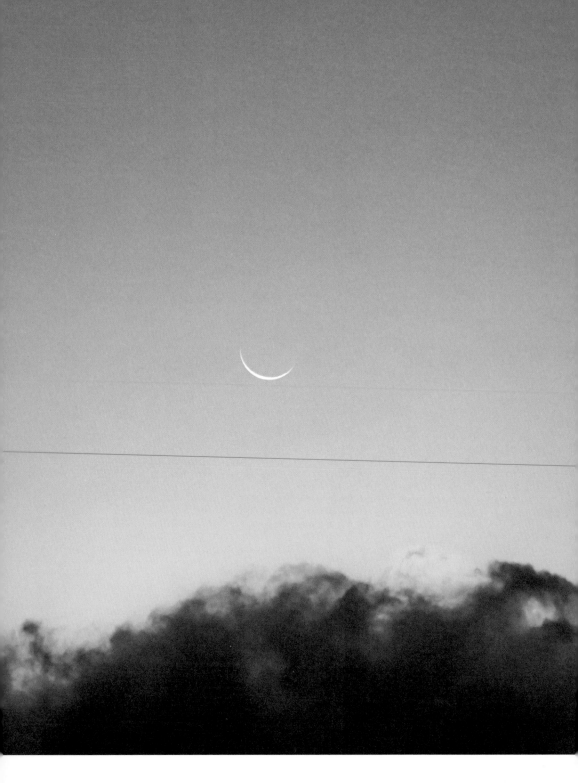

112 Forever shifting and rising across the night skies in a perpetual dance with the sun, our moon is a force we are forever tied to

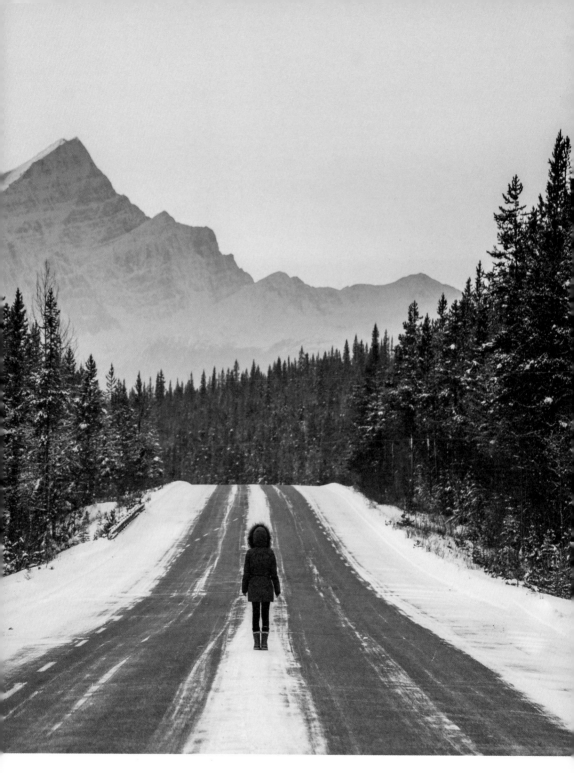

Soft, warm colours fills the sky as I wander within a frozen landscape of jagged ice-capped peaks, towering mountains and snow-lined pine trees. Jasper, Canada.

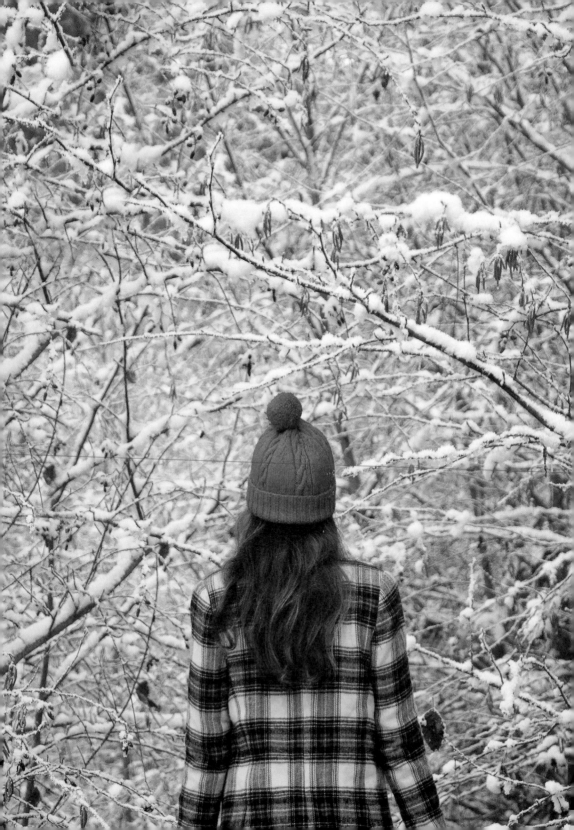

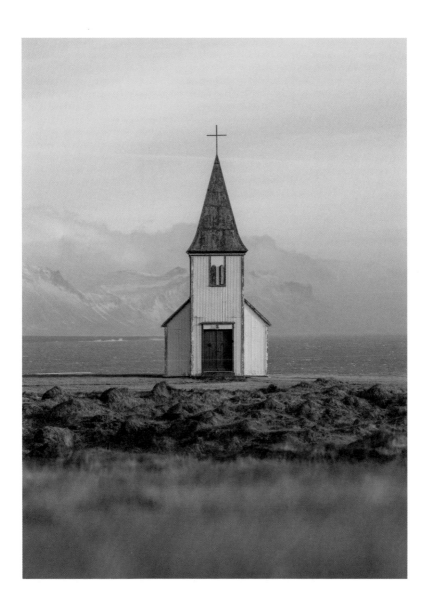

Left A moment to slow down and notice the snow fall silently around me, covering the branches in a blanket of white. Yosemite National Park, USA. **Above** A quaint little church found on the coast of Snæfellsnes Peninsula, Iceland

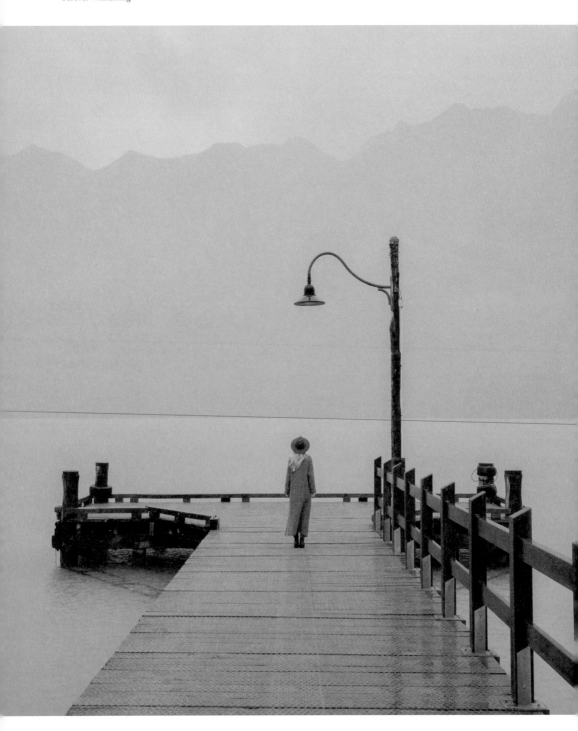

Wandering within the softness of the mist. The changing light and shifting weather of the mountains leave the entire landscape in a blue haze. Glenorchy, New Zealand.

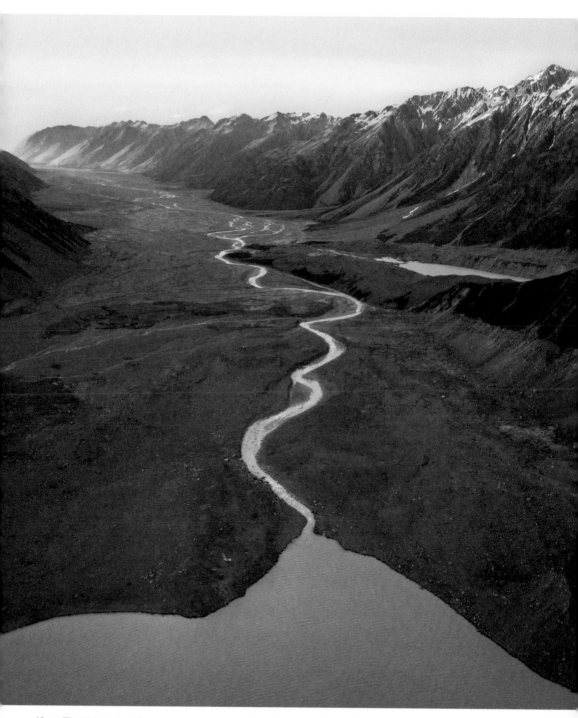

Above These lakes and winding rivers are the result of receding glaciers; melted water flows from these ice forms and fills the valley floor, reminding us of the landscapes that once existed. Southern Alps, New Zealand. **Overleaf** Watch the mountains fade into the night and the sky light up with a thousand tiny stars. Cradle Mountain, Australia.

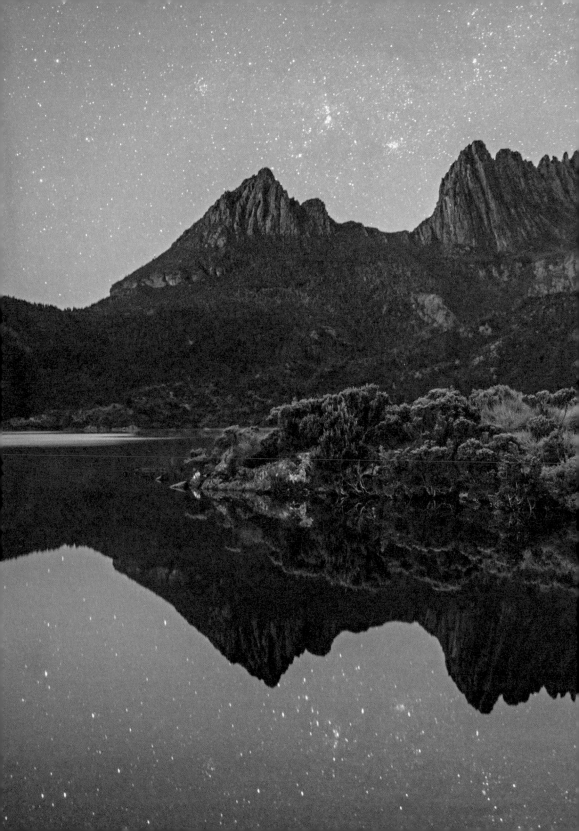

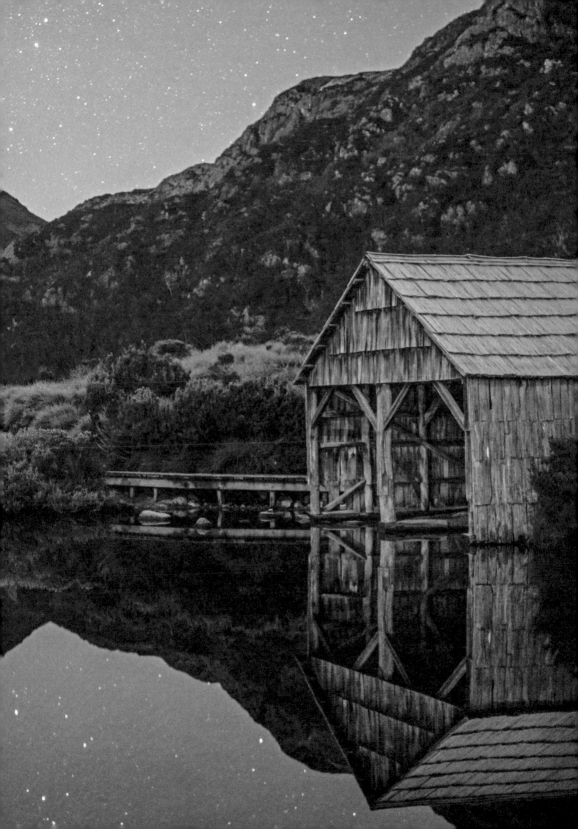

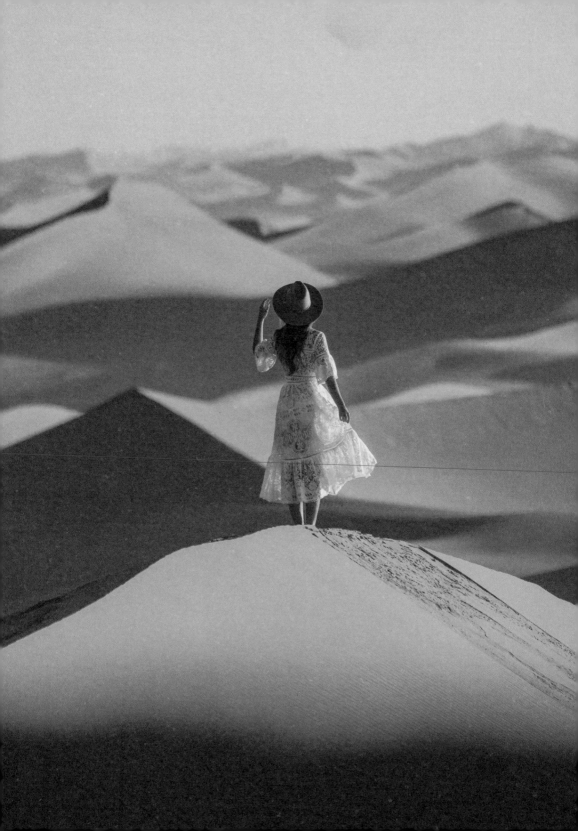

Our natural world is a place that feels familiar – a feeling hidden deep within our bones.

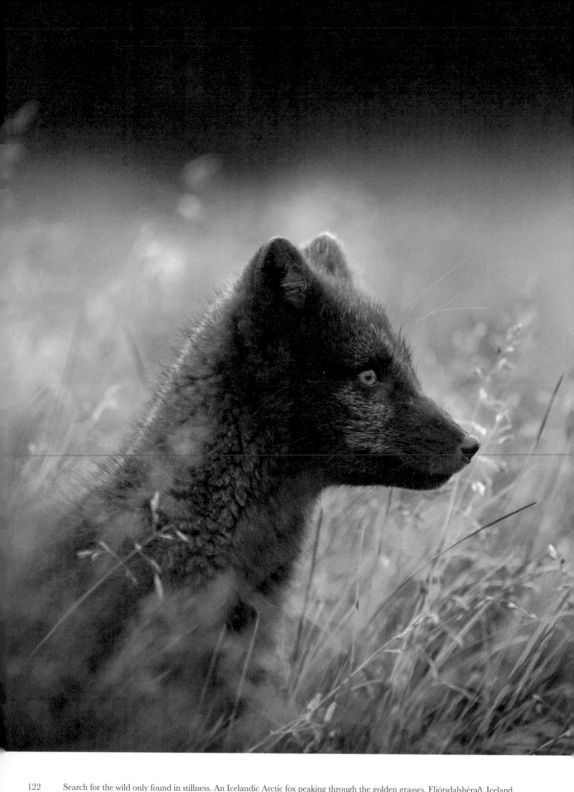

Search for the wild only found in stillness. An Icelandic Arctic fox peaking through the golden grasses. Fljótsdalshérað, Iceland.

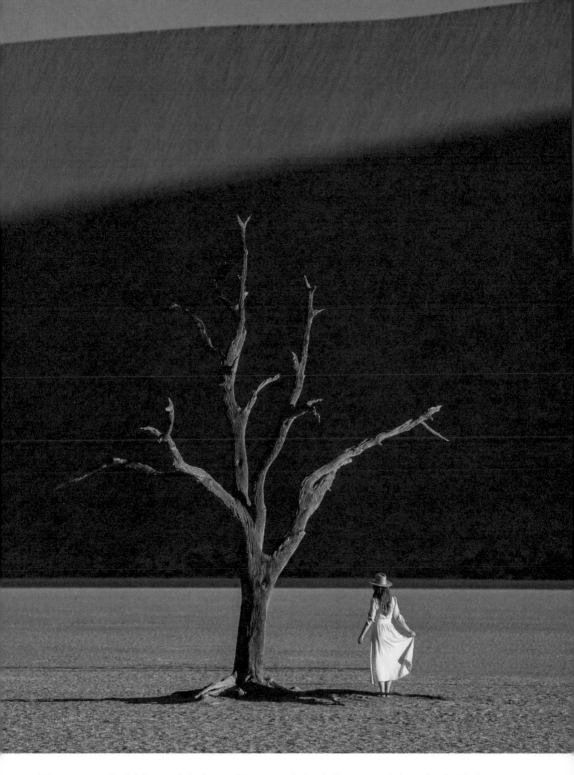

When our sun casts harsh light across the landscape and forms strong shadows, it allows us to see the beauty found within the patterns of light and darkness. Sossusvlei, Namibia.

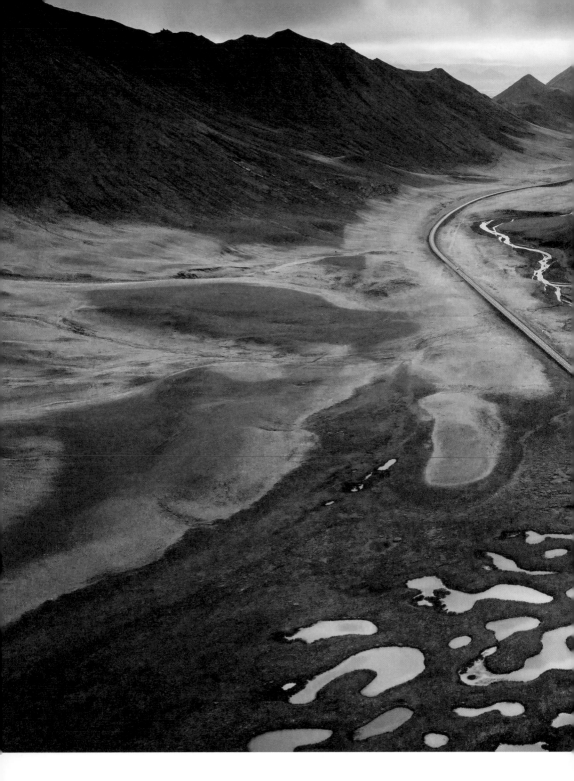

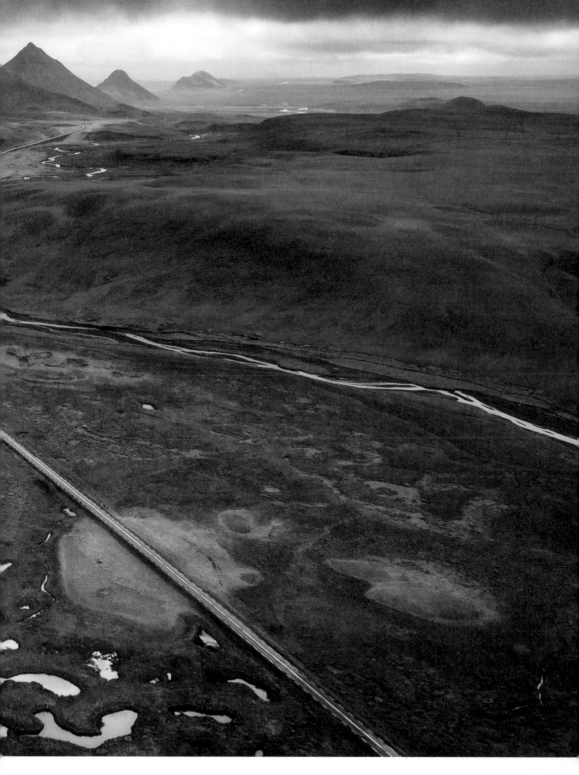

Escaping to what feels like another planet. This land lost in time is shaped by volcanoes, wind, water and ice – a place full of surreal and seemingly uninhabitable landscapes. Mývatn, Iceland.

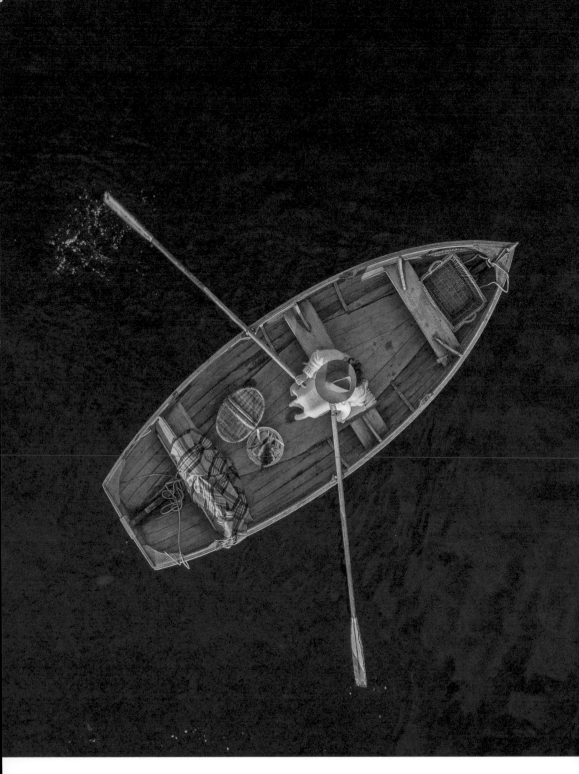

In places where time stands still, enjoy the simple things in life, like rowing a boat out to sea and listening to the sound of the waves. Satellite Island, Australia.

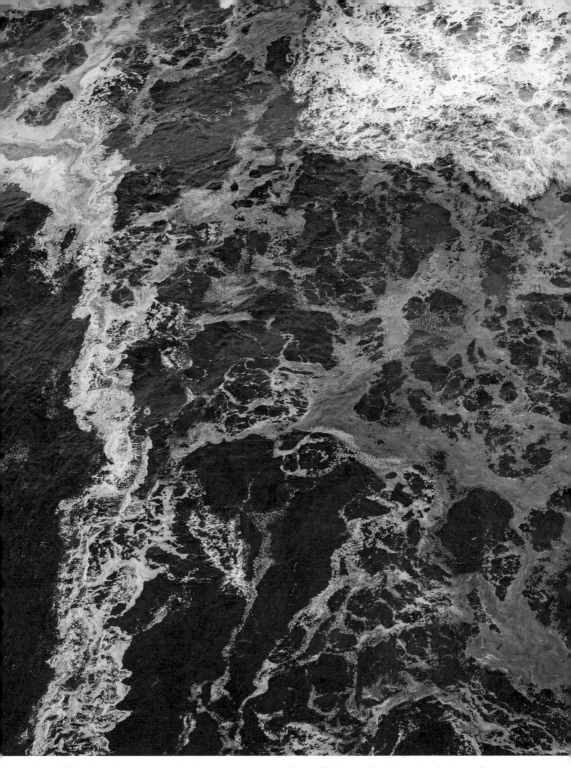

Above Wild colours and patterns created by the constant movements of the sea. Weaving together rich tannin-stained waters from the surrounding rivers mixed with the inky black salt water of the sea. Tasmania, Australia. **Overleaf** Early morning mist silently floats across the lake and slowly dissolves to reveal an almost perfectly still reflection. Mount Hood, USA.

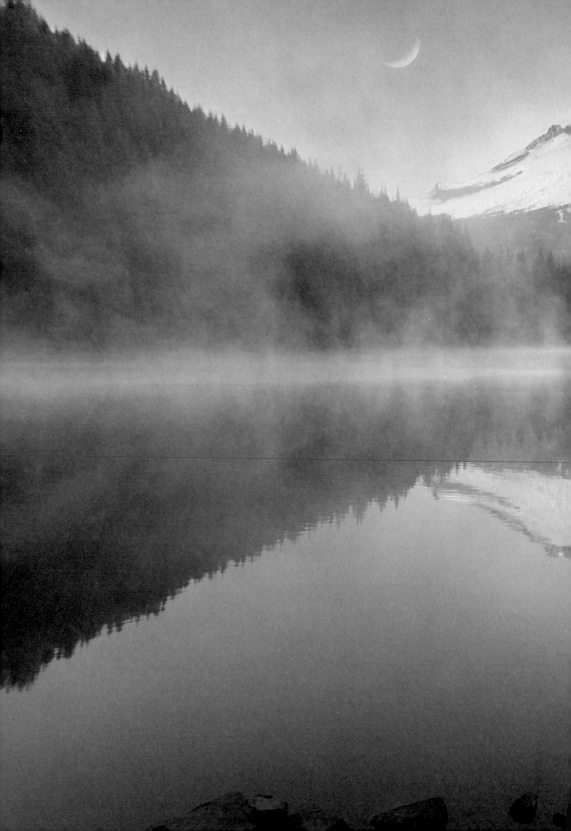

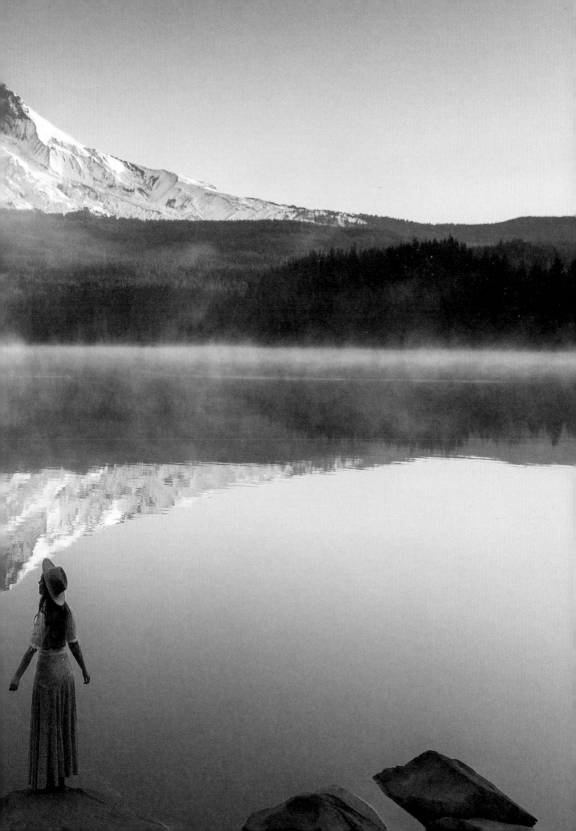

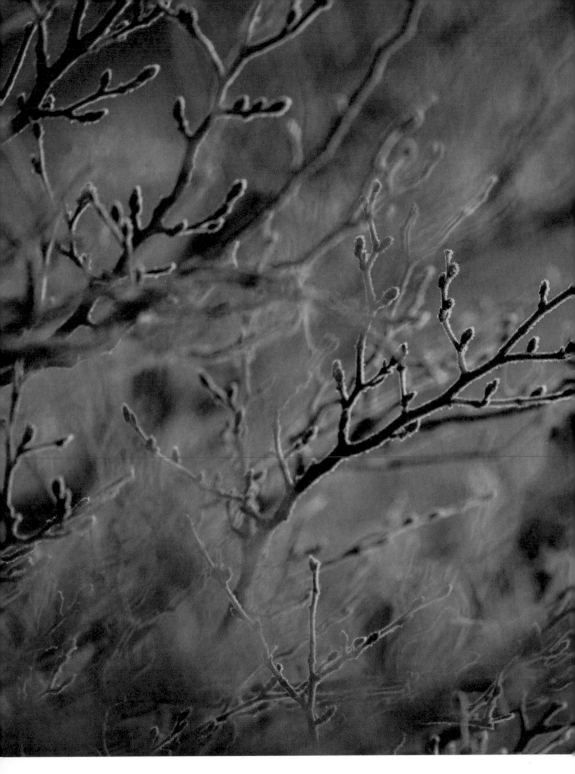

Bare, frozen branches in the bitter cold of winter, waiting for their time to bloom. A transformative natural cycle, reminding us to appreciate the return of spring when our world comes alive with new life. Tasmanian Central Highlands, Australia.

From the smallest forms of life to the interconnected complexities of our forests, we are all a part of a diverse ecosystem, making up the beauty of our living planet

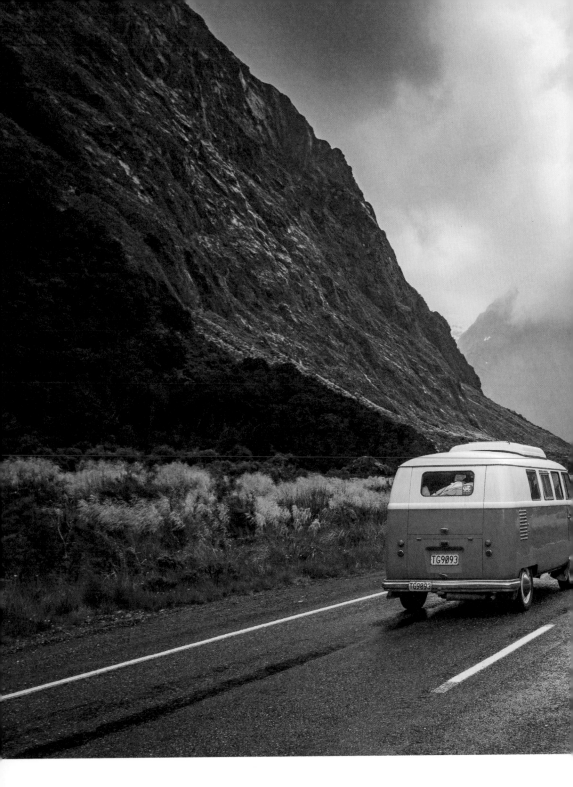

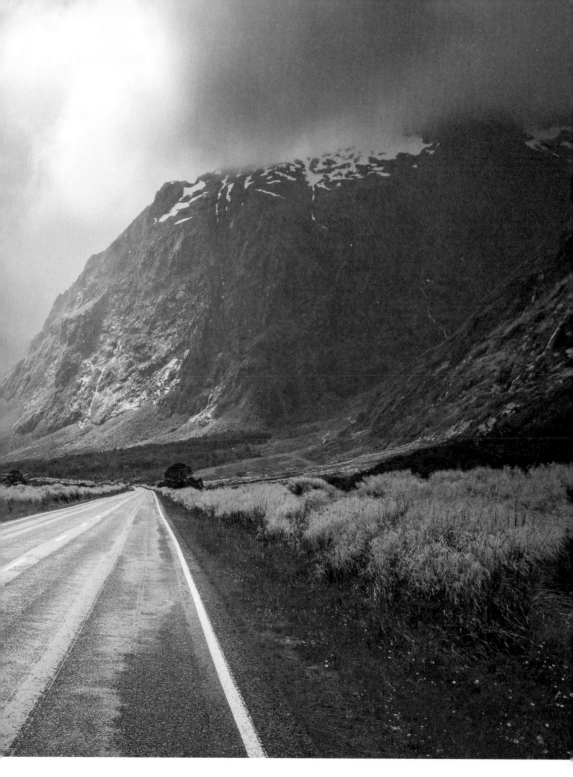

On the road to Milford Sound, an ancient landscape formed millions of years ago waiting to be explored. These glacier-carved valleys were once flooded by the sea but are now home to an abundance of new life. Fiordland National Park, New Zealand.

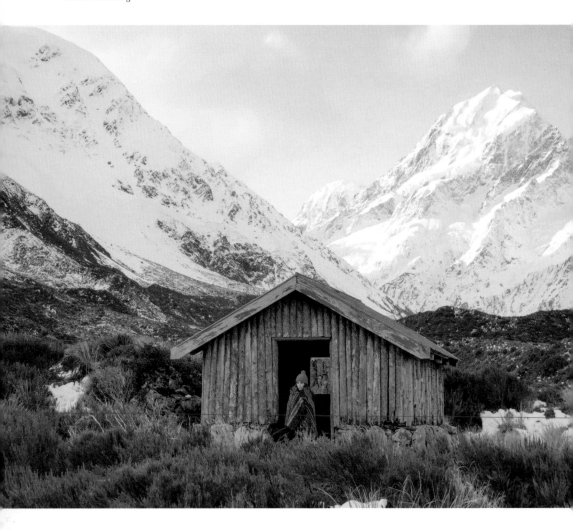

Finding warmth in the coldest of places. A rustic wilderness hut deep in the valley beneath Aoraki, New Zealand.

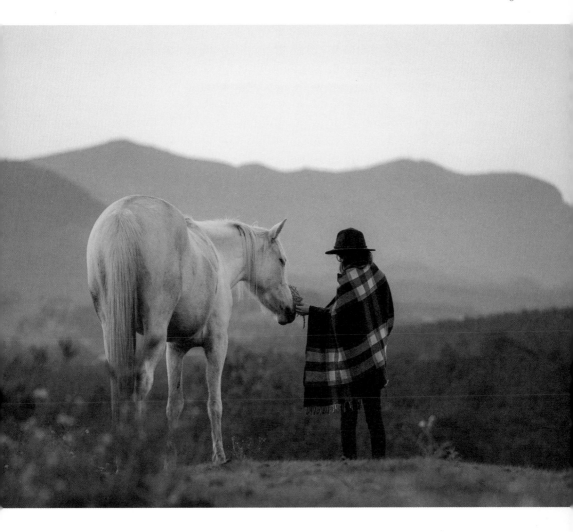

Above There is a harmony and balance found only in our natural world; a deep-rooted connection that can be found all around us when we choose to look. Northern Rivers, Australia. **Overleaf** Amongst the wildflowers there is a place to bloom and grow freely in the natural world. Northern Rivers, Australia.

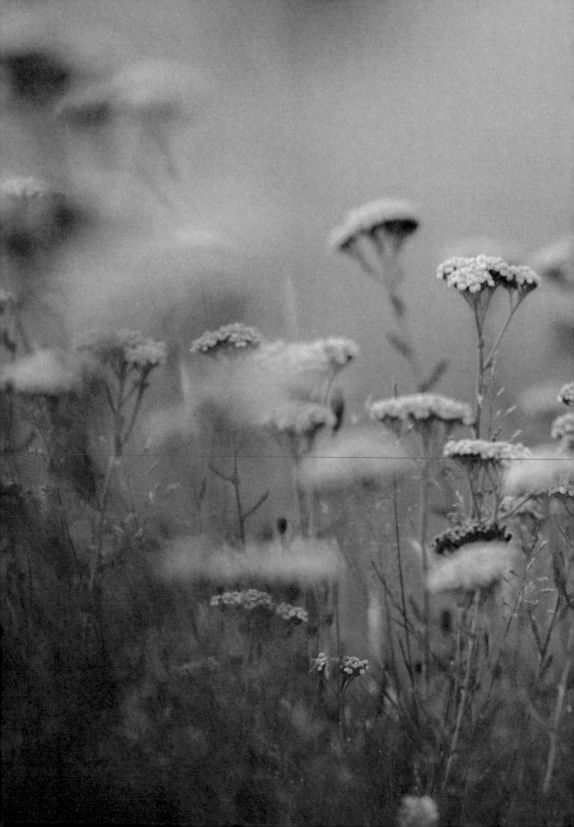

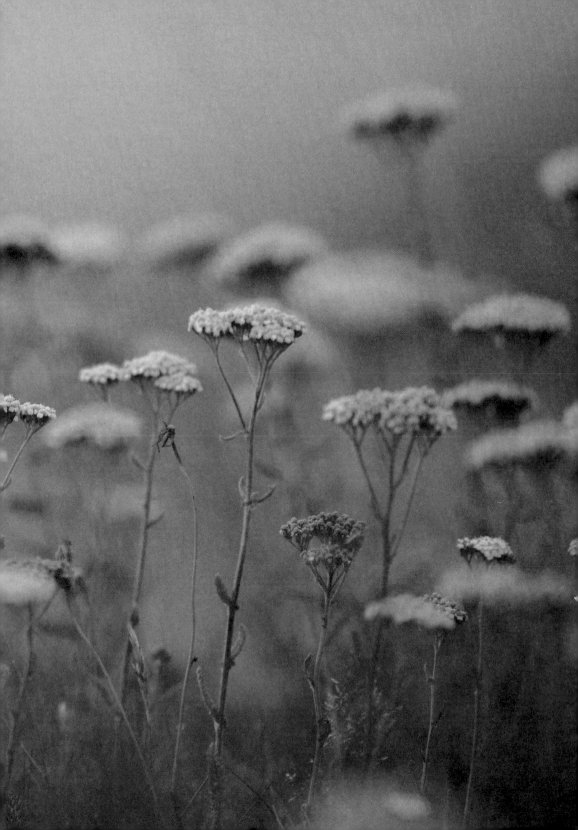

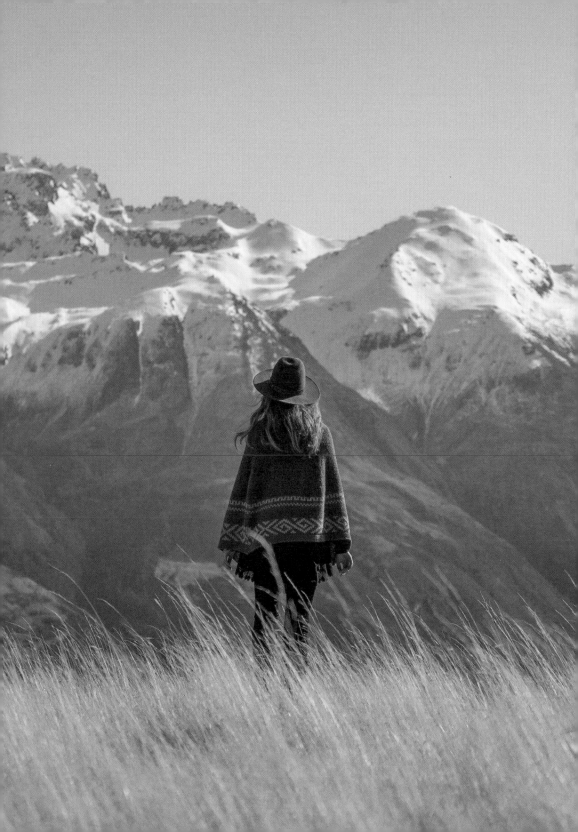

In the wilderness of the mountains, there's a stillness that can only be found within these living landscapes.

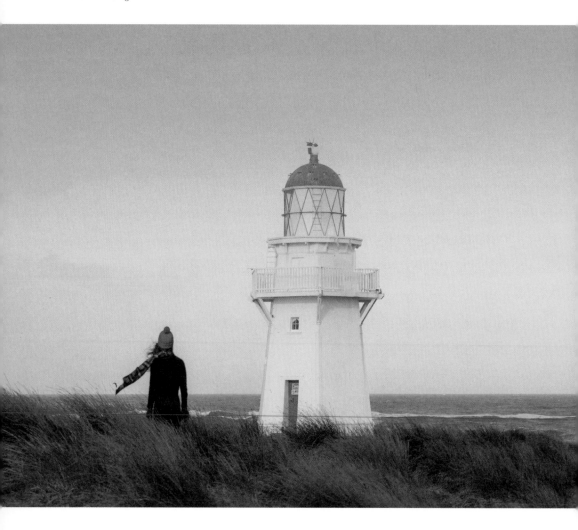

Surrounded by sweeping golden beaches, the wildness of the sea and the power of the wind, a historic lighthouse sits secluded overlooking the ocean. Waipapa Point, New Zealand.

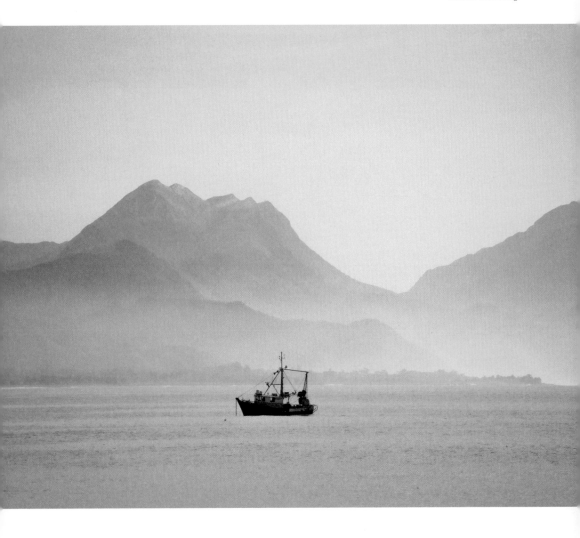

Above A fishing boat drifts in the soft sea mist, surrounded by rugged peaks towering above the coastline. Kaikoura, New Zealand.
Overleaf First light of the rising sun shines through an ethereal world of ice – an ocean speckled with frozen pieces of the past.
Ilulissat, Greenland.

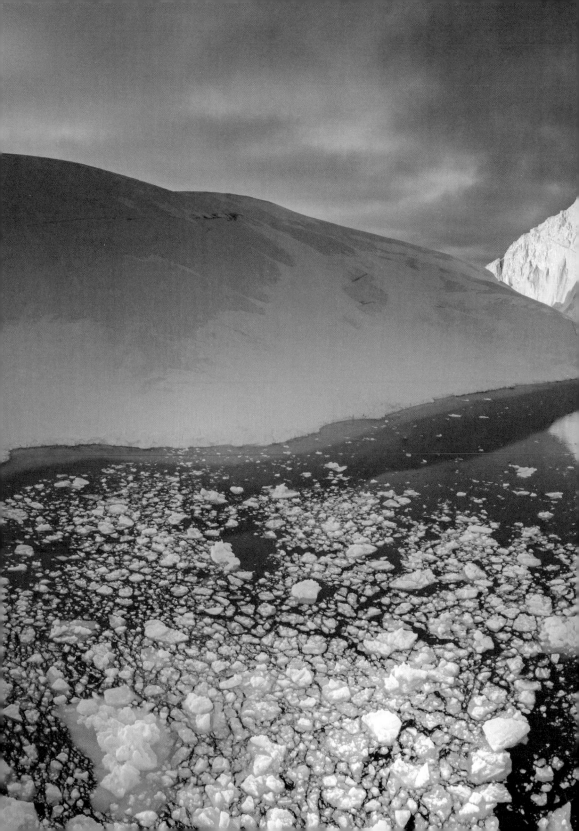

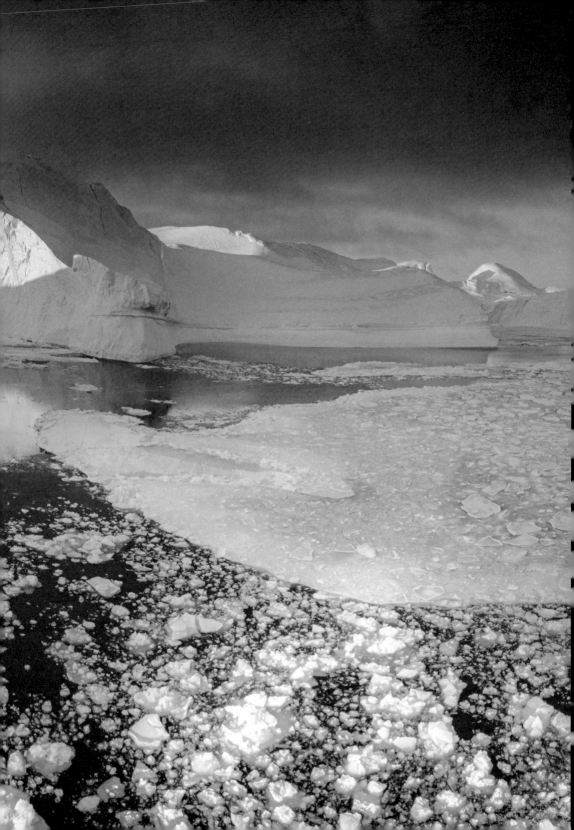

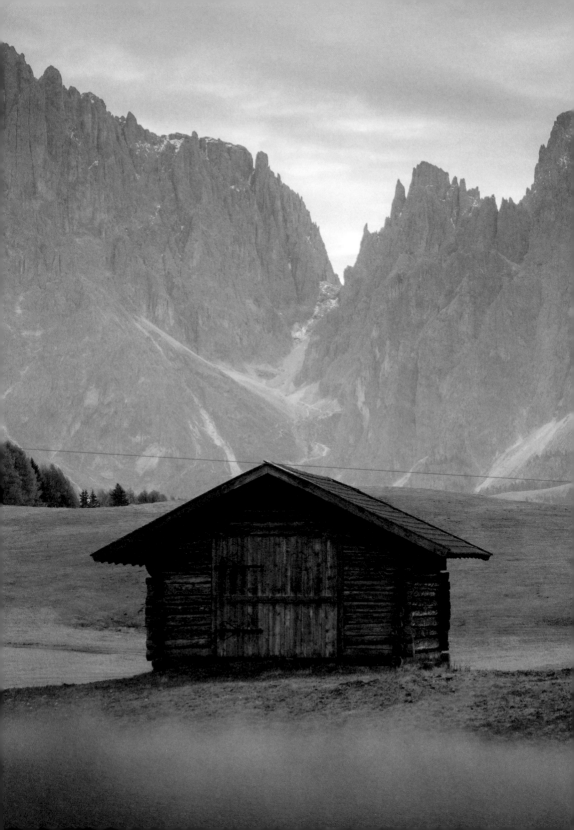

Left A little wooden cabin tucked away in the mountain valleys of Alpe di Siusi, Italy. **Above** Light catches all that we see. It glows, transcends and fills us with warmth. Marrakech, Morocco.

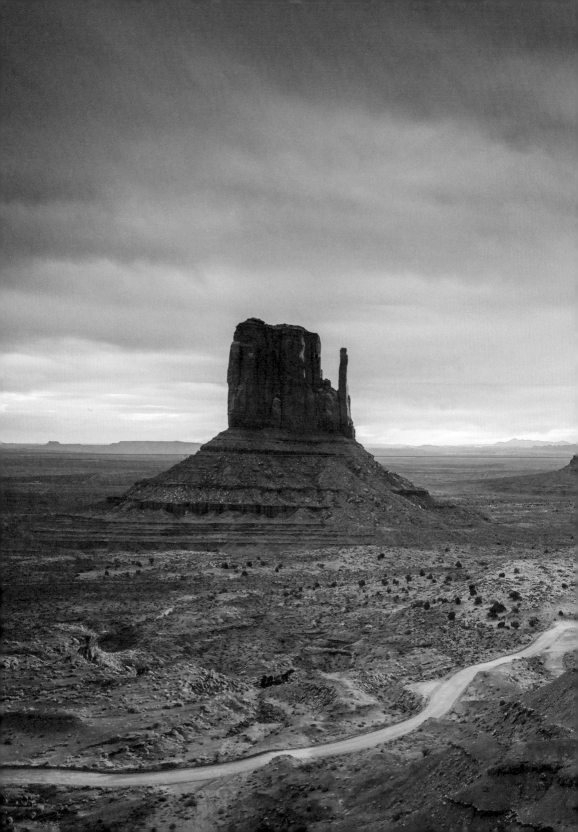

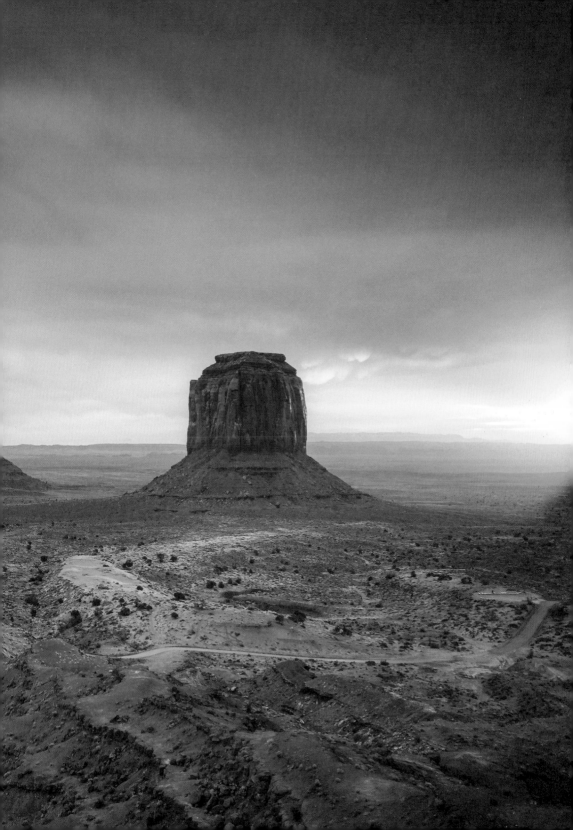

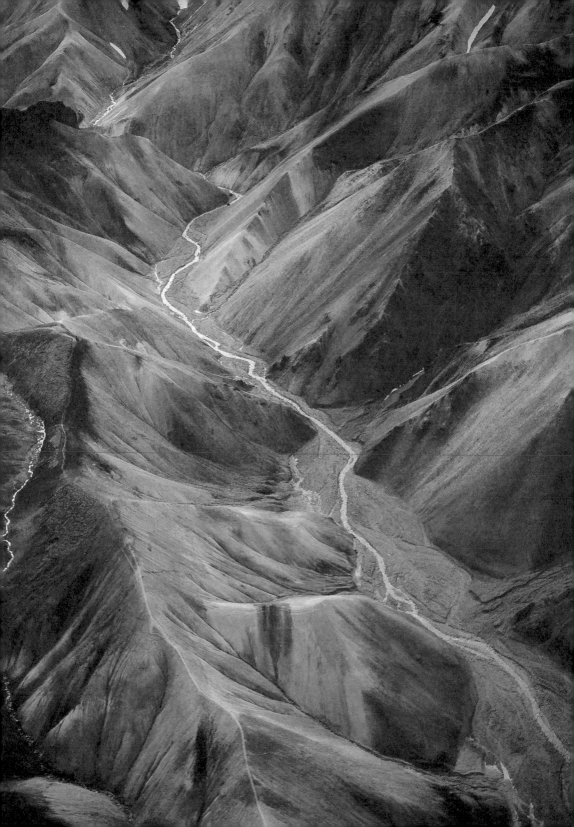

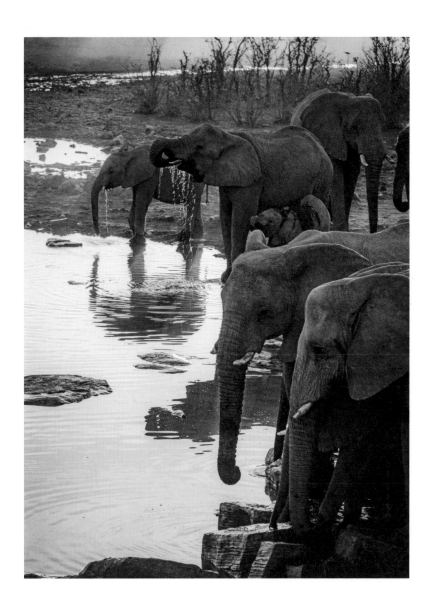

Previous At sunset this spiritual landscape glows a deep burnt red. Monument Valley, USA. **Left** The painted landscapes of Landmannalaugar, Iceland – a geothermal wonderland full of rich colours that changes with the light **Above** A breeding herd of elephants quenches their thirst in the golden light spilling through the dust. Etosha, Namibia.

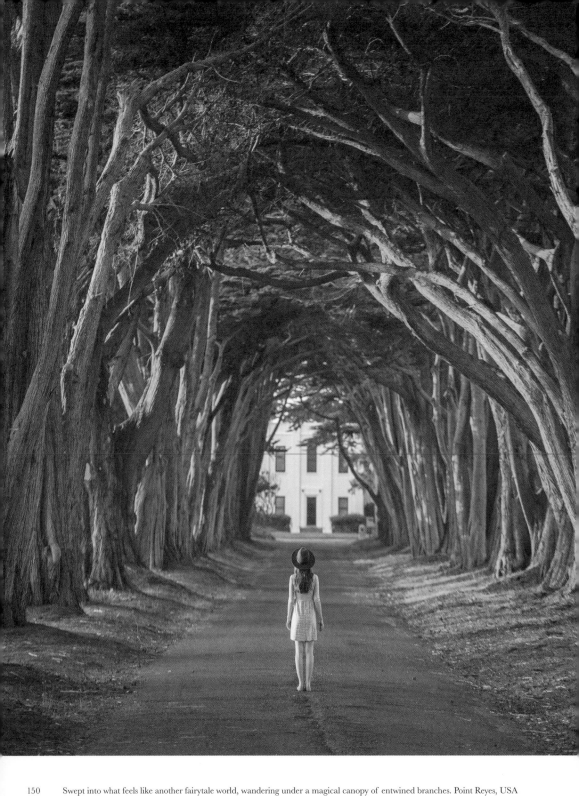

Swept into what feels like another fairytale world, wandering under a magical canopy of entwined branches. Point Reyes, USA

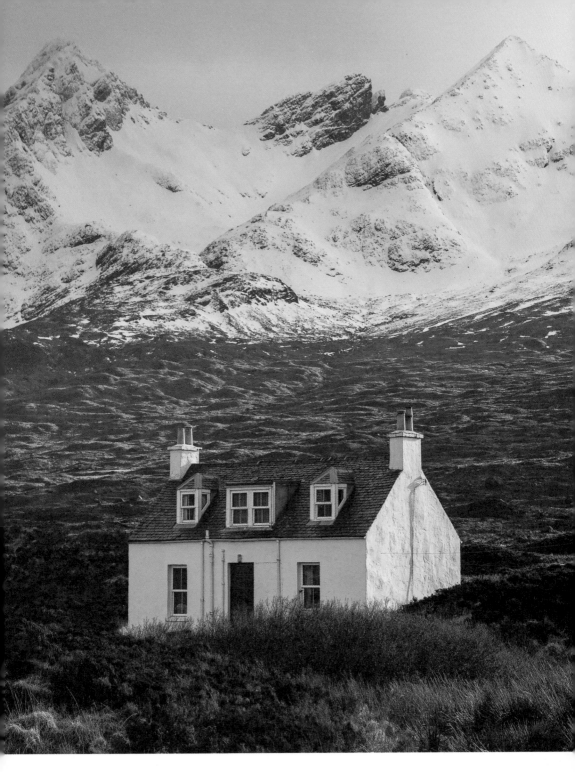

Finding a sense of home within the mystical landscapes of the Scottish Highlands. When the snow covers the mountain peaks in winter, a sense of mystery fills this land. Isle of Skye, Scotland.

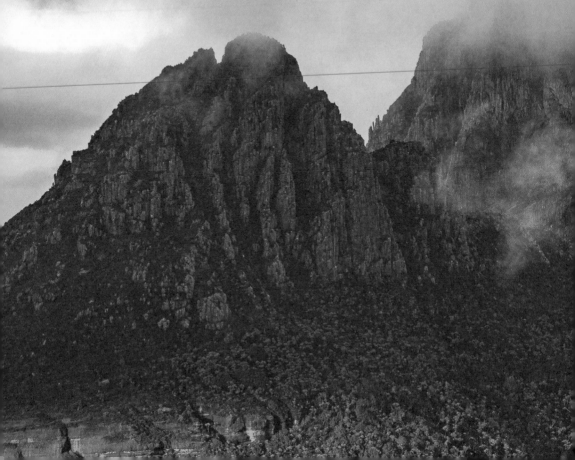

Light moves across the sky and fills the land with a soft, warm glow.

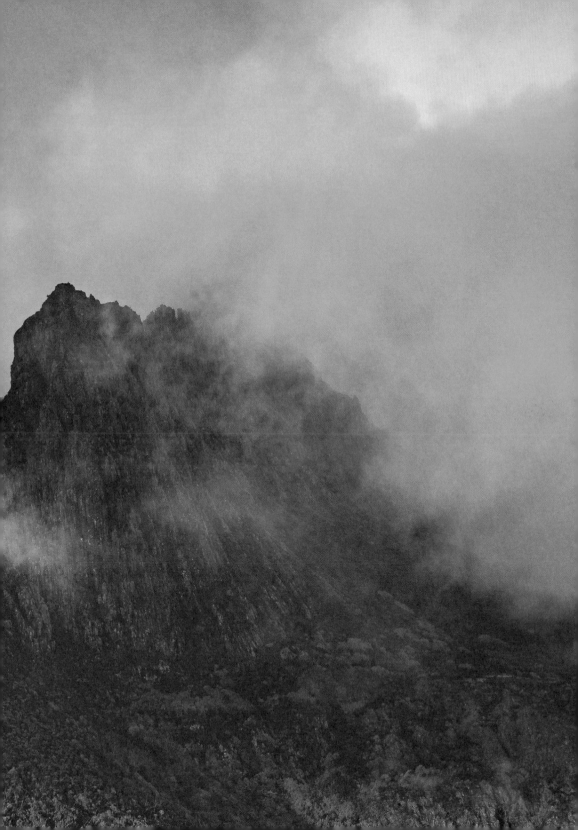

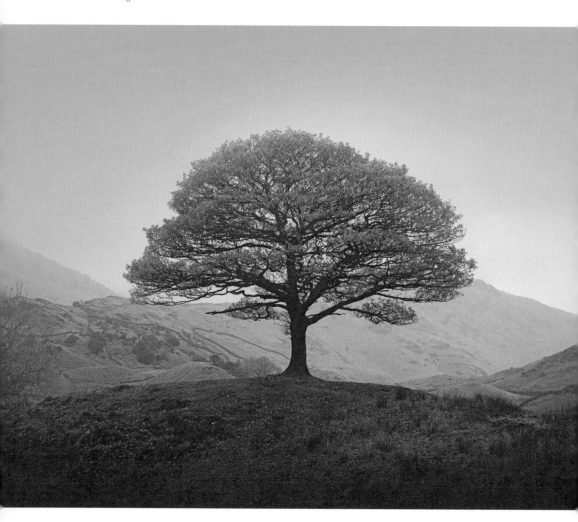

Every root, every branch and every leaf exist in harmony. Lake District National Park, United Kingdom.

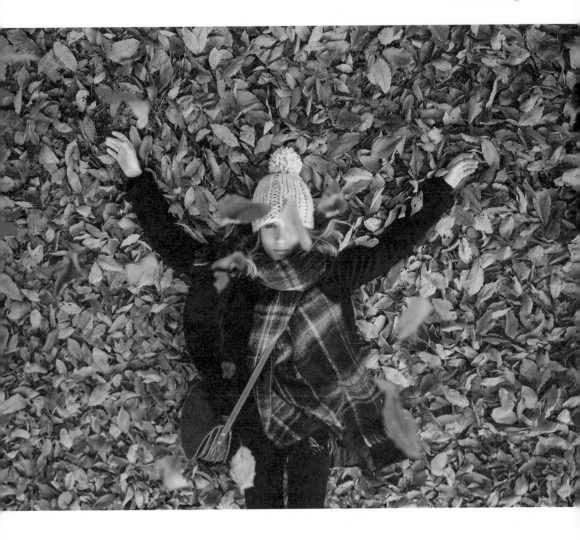

The changing seasons awaken our senses, from the rustle of autumn leaves beneath our feet to the cold winter air on our skin. Shirakawa, Japan.

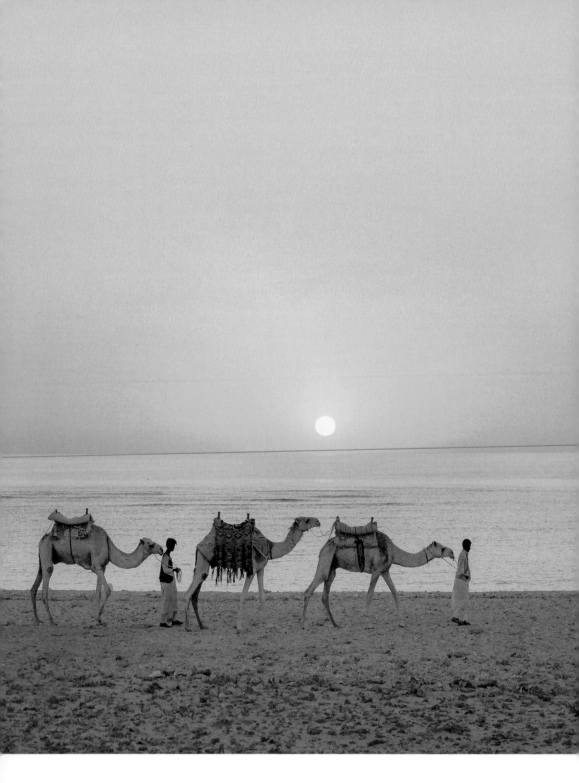

Sunrise over the Red Sea. An ancient land home to nomadic tribes living at one within the wilderness. Marsa Alam, Egypt.

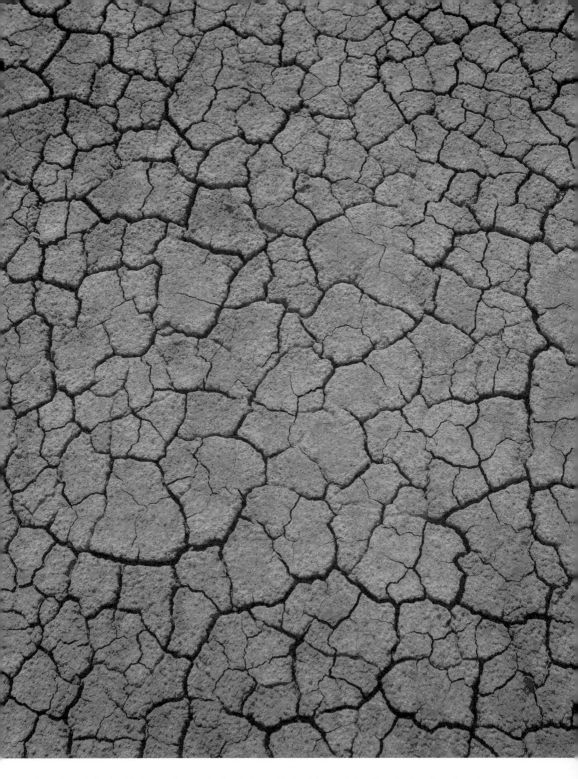

A transformative land, void of water; the network of cracks in our dried earth is a reminder of how fragile and interdependent our planet is. Broome, Western Australia.

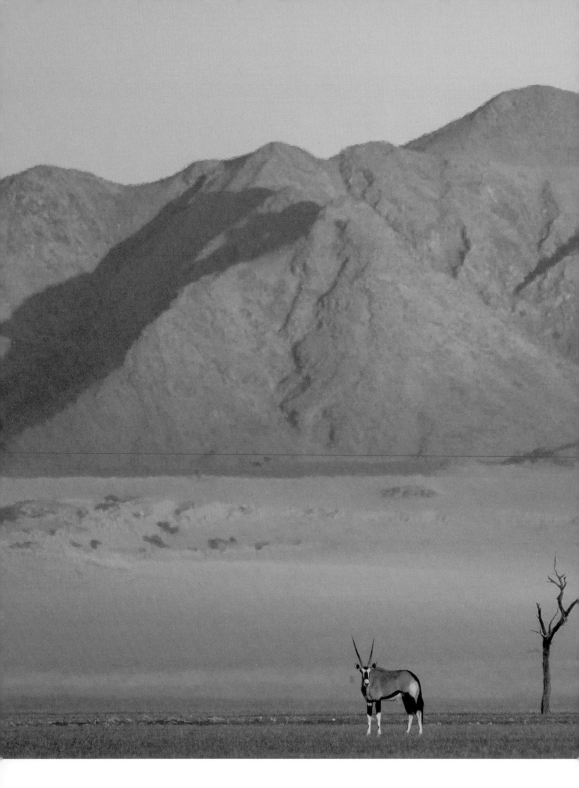

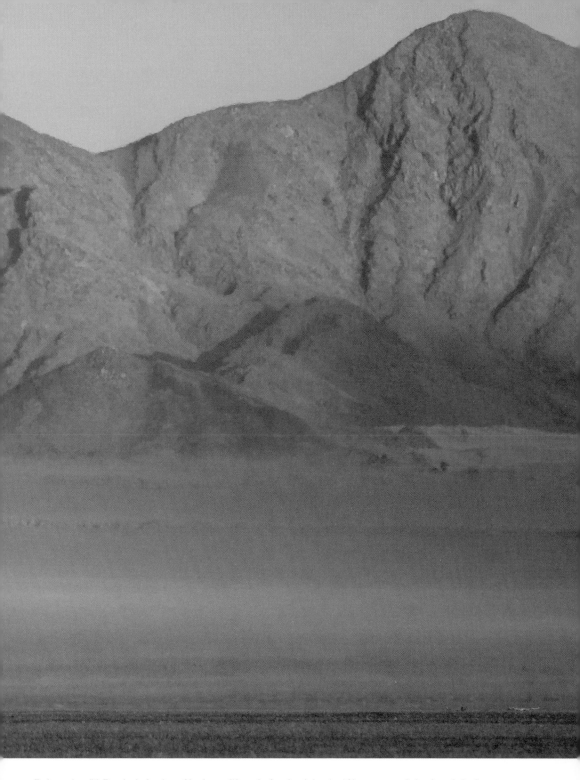

Embrace the wild. Even in the harshest of landscapes life can be found to thrive. An African oryx wandering through the desert plains of Maltahöhe, Namibia.

There is always a path back to our natural world. Take the time to observe and be present, so we can re-ignite our sense of wonder.

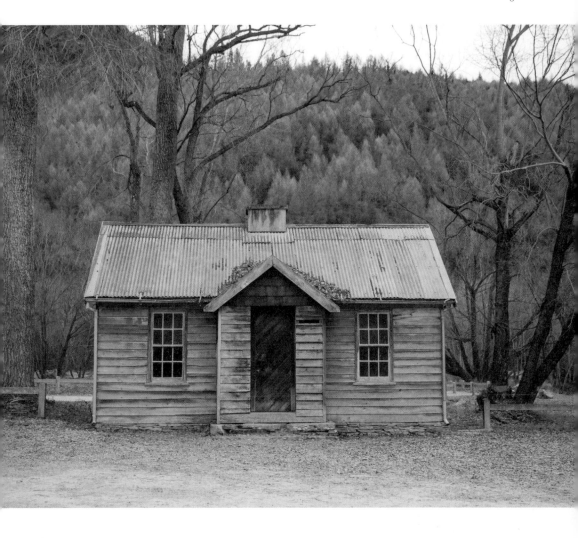

The warm natural colours of this historical wooden cottage blend together with the natural surroundings. Arrowtown, New Zealand.

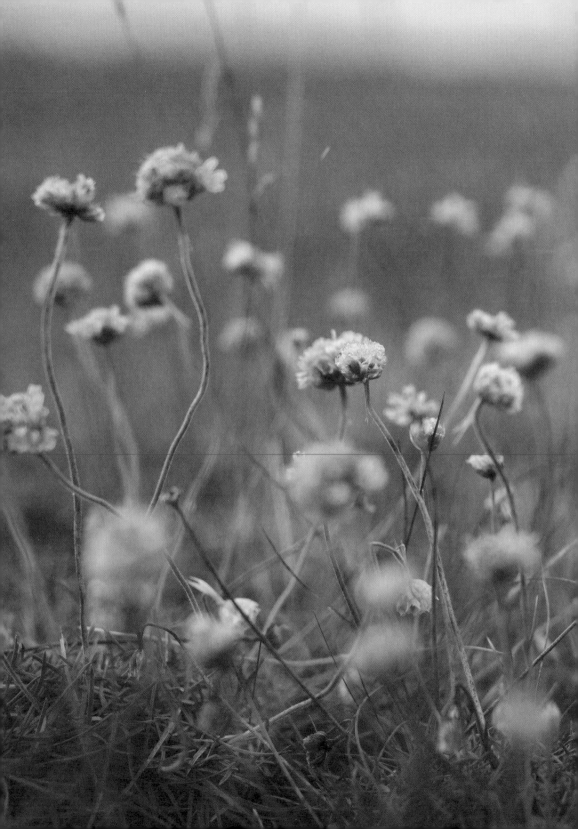

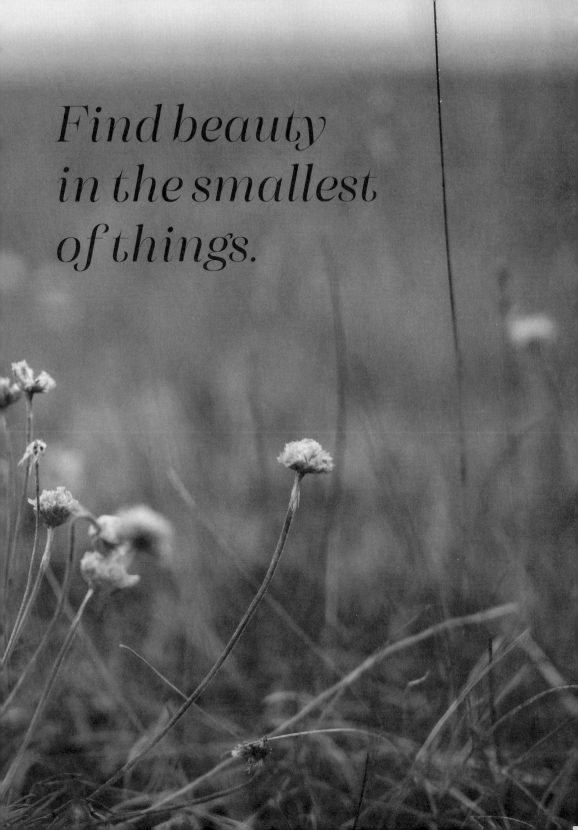

Find beauty in the smallest of things.

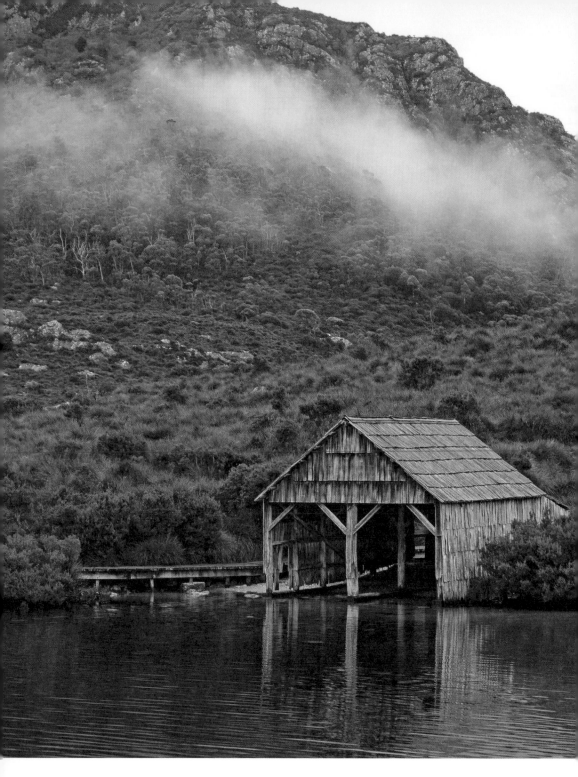

In the shadow of the mountains, a boat house sits nestled on the north-western shore of Dove Lake. A landscape filled with golden button grass plains and majestic mountain peaks. Cradle Mountain, Australia.

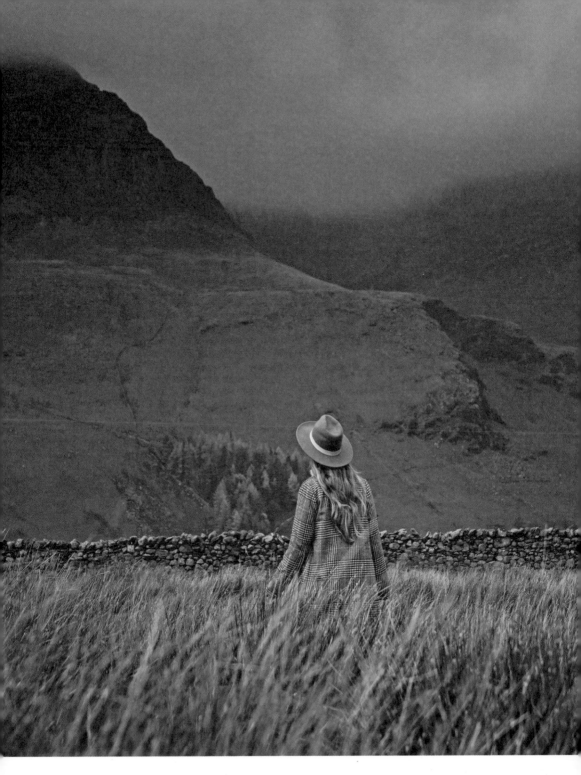

Wandering through the British highlands discovering golden grass, winding roads lined with stone walls and quaint cottages hidden throughout the historic landscape. Lake District National Park, United Kingdom.

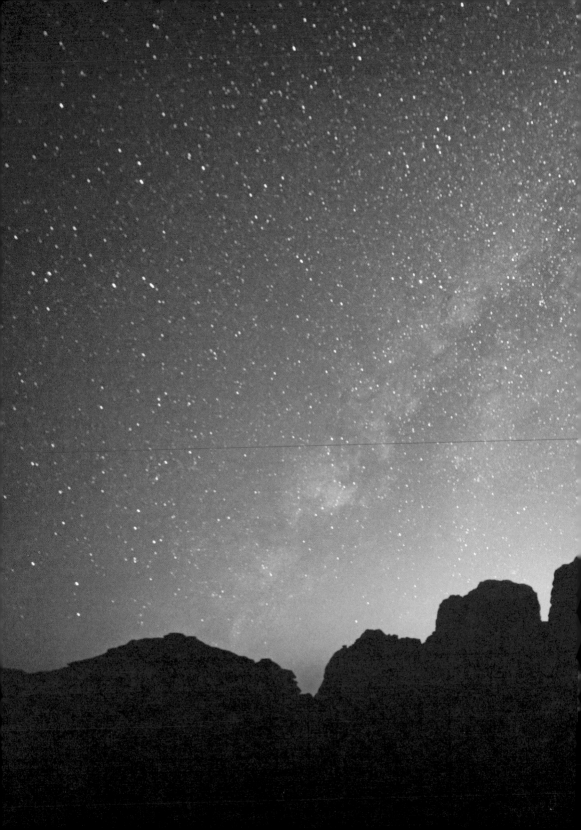

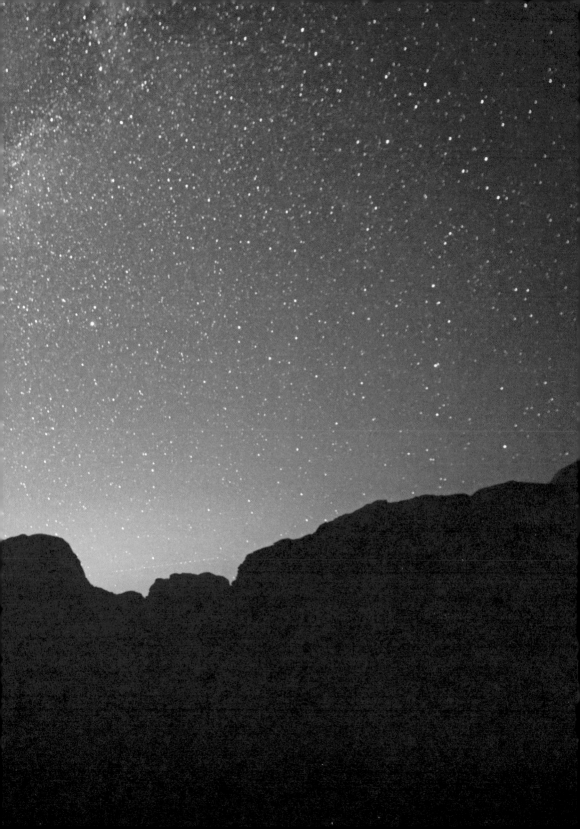

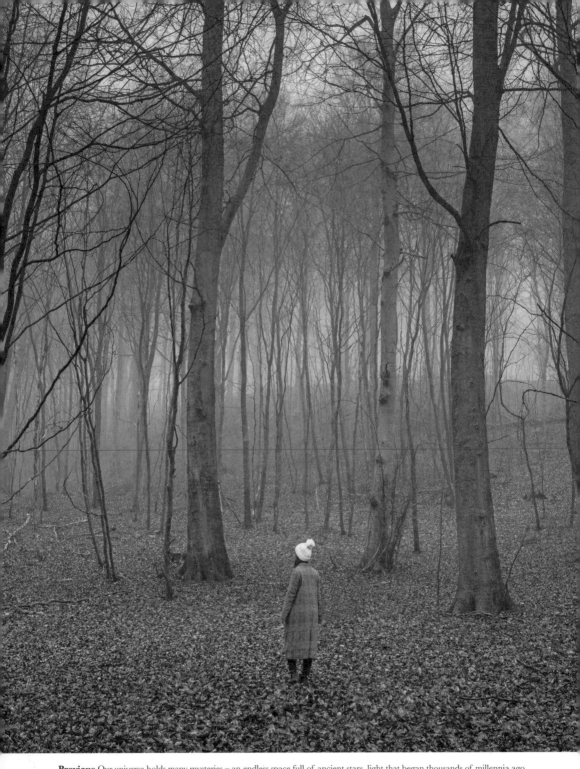

Previous Our universe holds many mysteries – an endless space full of ancient stars, light that began thousands of millennia ago, sparkling overhead and dancing between the planets of our galaxy **Above** A layer of fog drifts between the woodlands and winter trees – a forest kept secret from the rest of the world. Møn, Denmark.

Above Listen and connect to nature in a deeper way – wander, gather and collect to experience the seasons **Overleaf** Glacier water flowing towards the ocean – a meandering journey through different landscapes before forming into braided river streams that drift out to sea. Selfoss, Iceland.

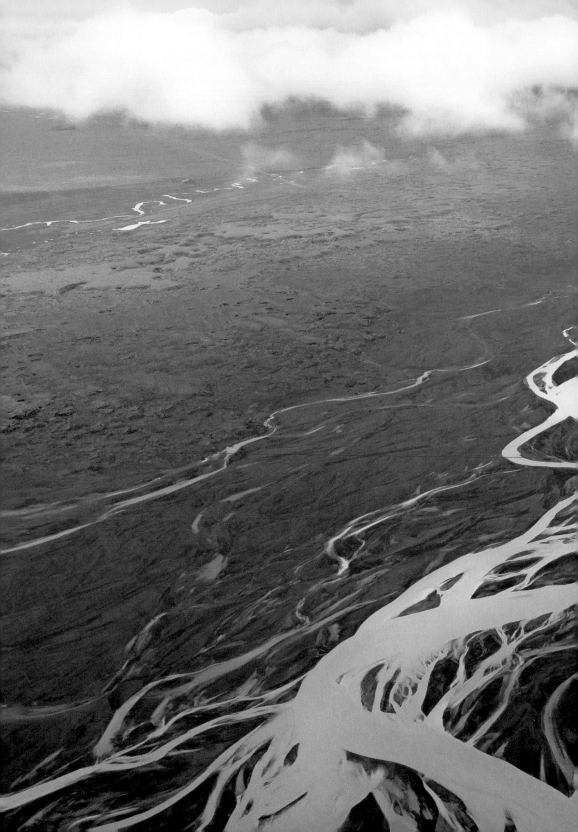

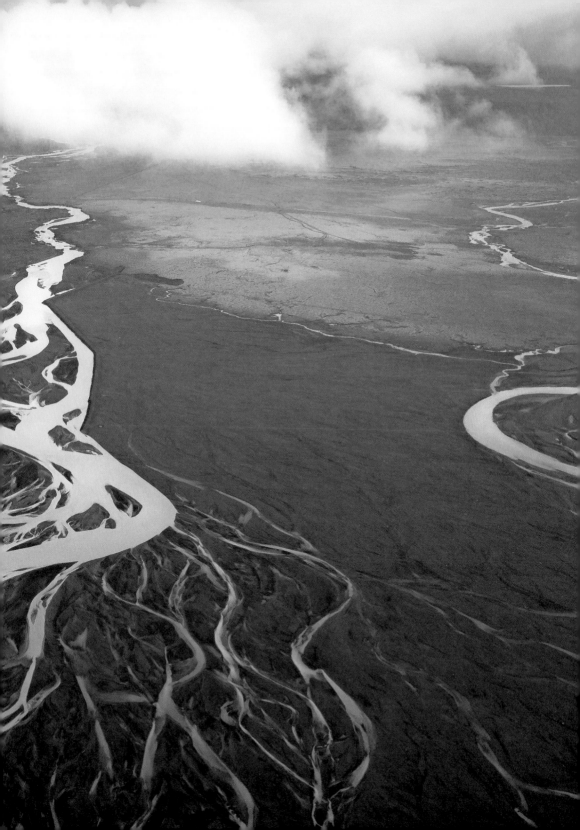

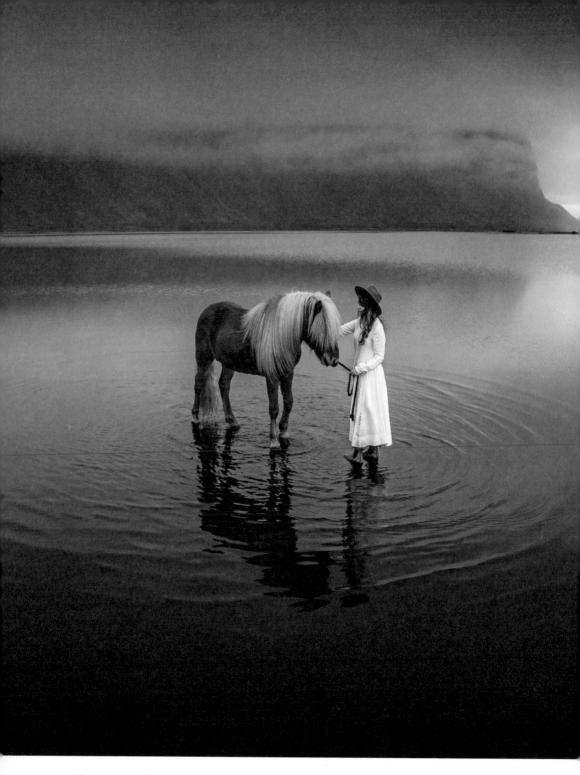

There are some moments that stay with you forever, dream-like encounters with nature that leave you inspired to seek a heightened connection with all life on Earth. The surreal black sand beach of Stokksnes, Iceland.

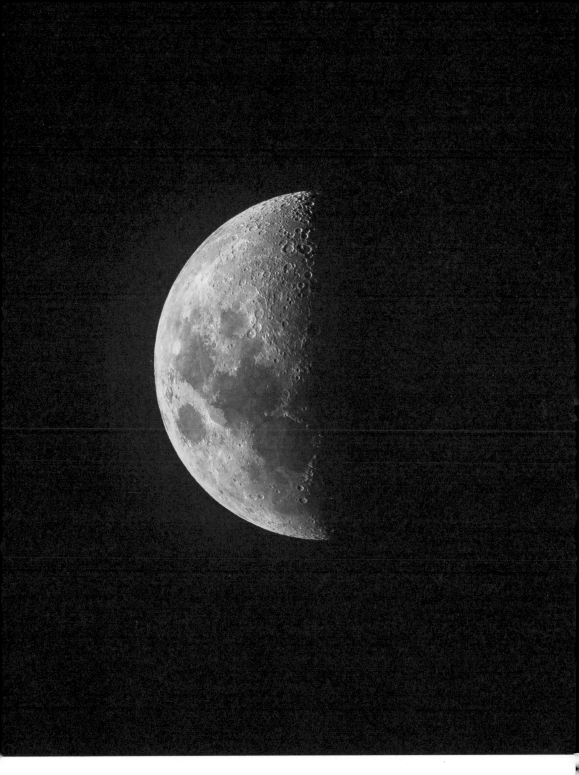

There is a mystery to our moon; a luminous astronomical body orbiting the Earth, controlling the tides and reflecting the sun's light in a series of phases as our planet obstructs the light.

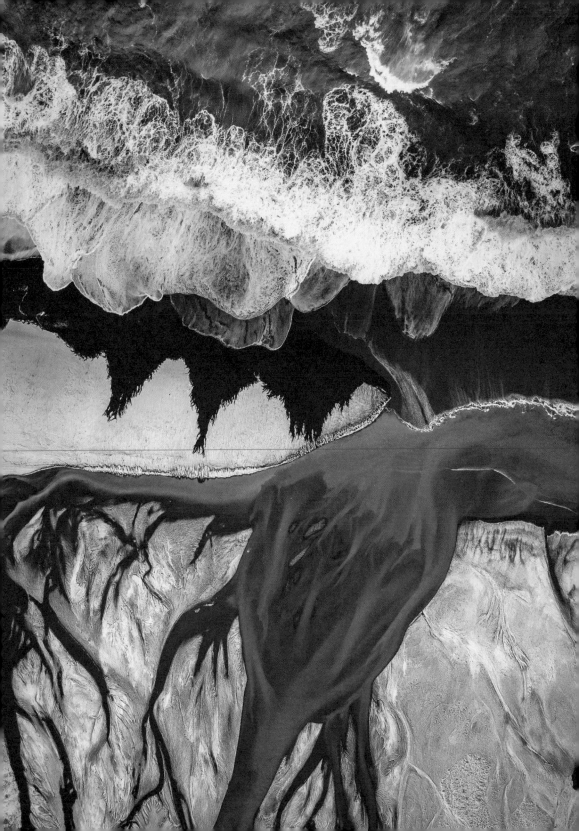

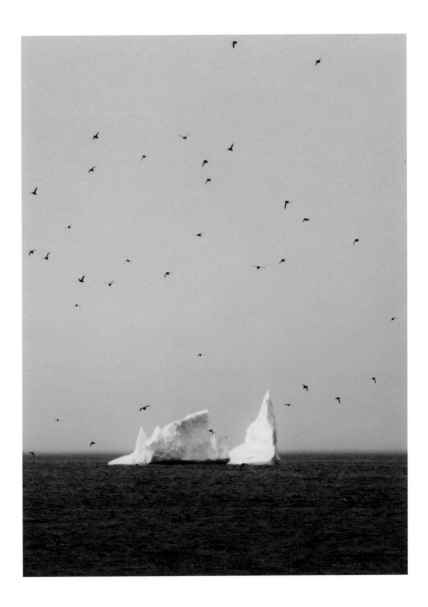

Left Where the flowing rivers meet the ocean, an ancient yet symbolic journey comes to an end. These patterns and landscapes are a reminder of the raw and wild forces of our natural world. Vik, Iceland. **Above** Every year thousands of icebergs break off from the glaciers in Western Greenland and make their journey south through the Atlantic Ocean. Twillingate, Canada.

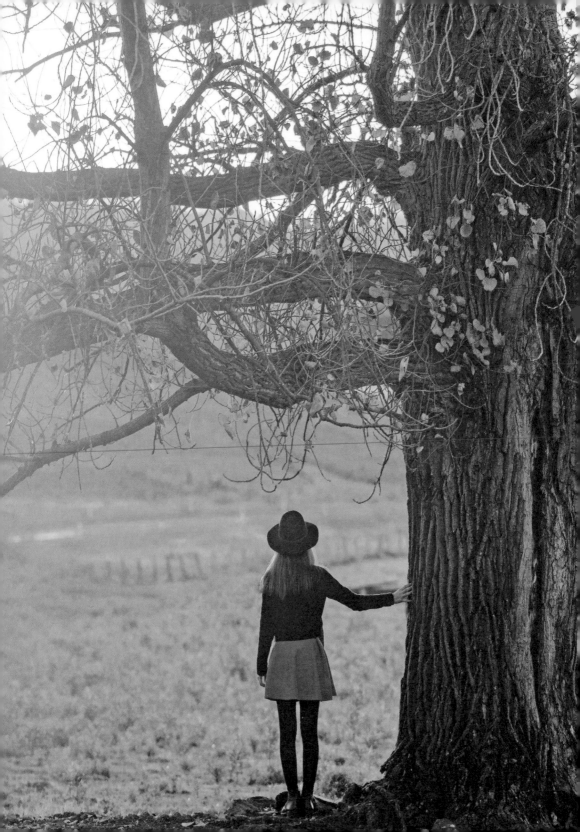

We are all part of nature's stories, living and breathing as one.

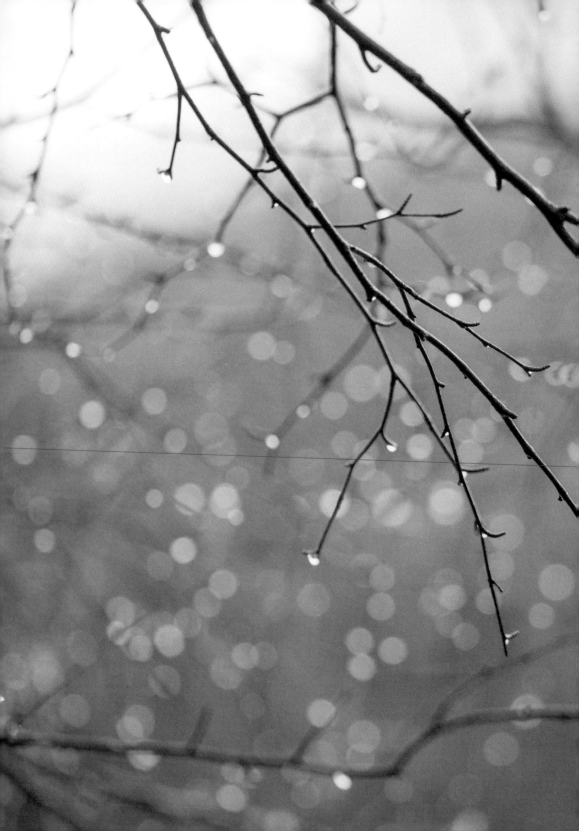

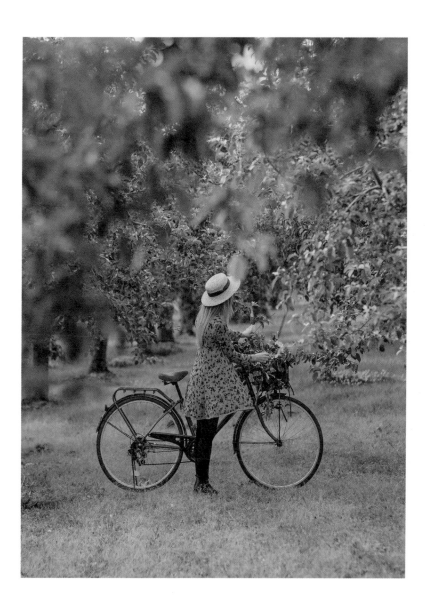

Left Walk deep into the forest, look up at the canopy high above and breathe the fresh air deep into your lungs. South Island, New Zealand. **Above** Spontaneous bicycle rides amongst the blooming apple trees. Aomori, Japan.

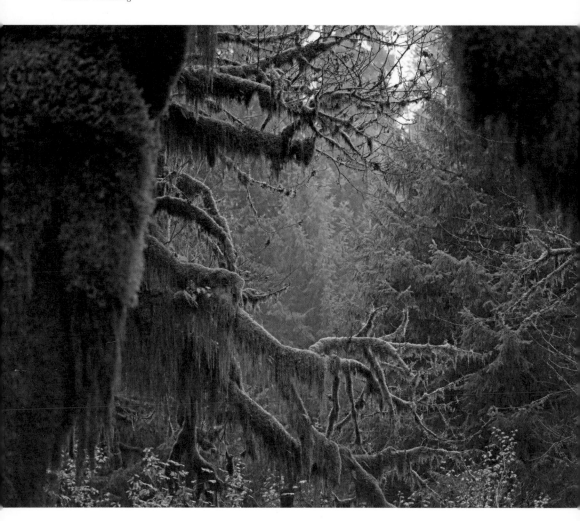

Notice how the sunlight transcends and glows between the trees, from the canopies all the way down to the tiny fragile grasses below.
These beautiful ancient trees began life thousands of years ago. Olympic National Park, USA.

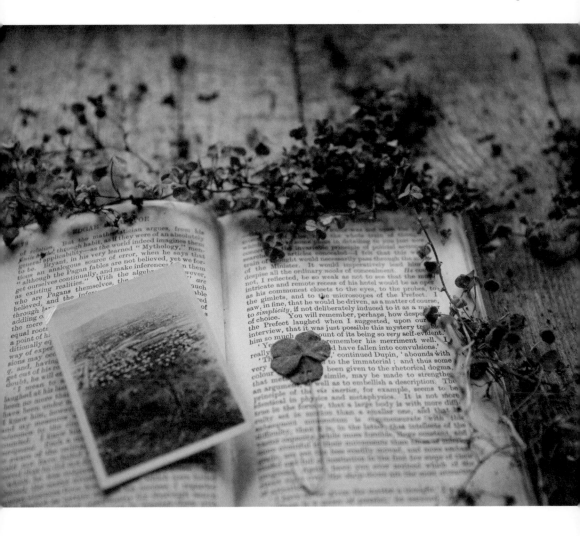

Above Re-wild your senses by finding ways to bring nature inside, surrounding yourself with greenery. **Overleaf** A dramatic storm rolling in over the green meadow valley. The Dolomites, Italy.

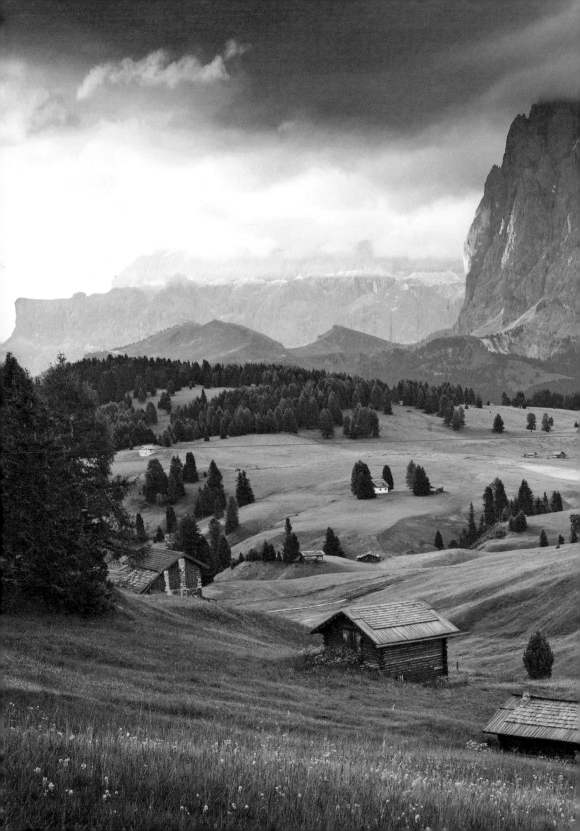

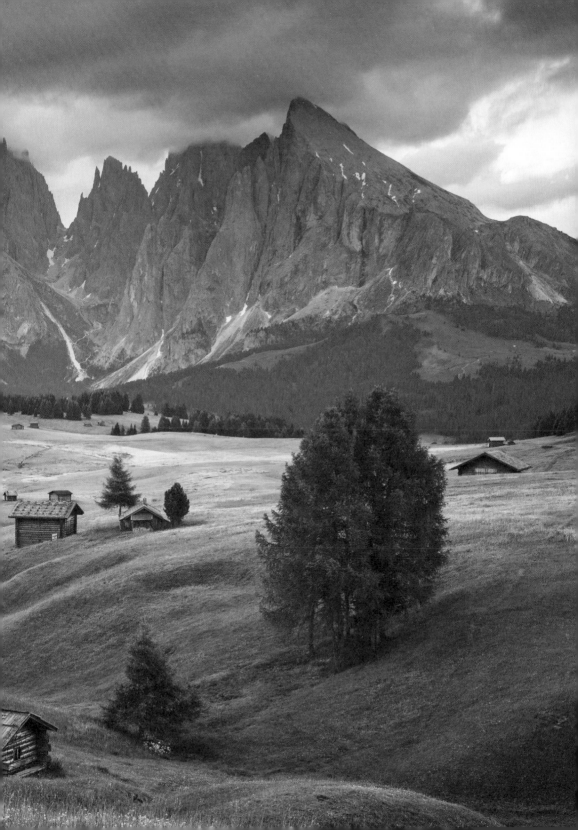

To breathe, to bloom, to grow ... amongst the wildflowers and into the heart of nature.

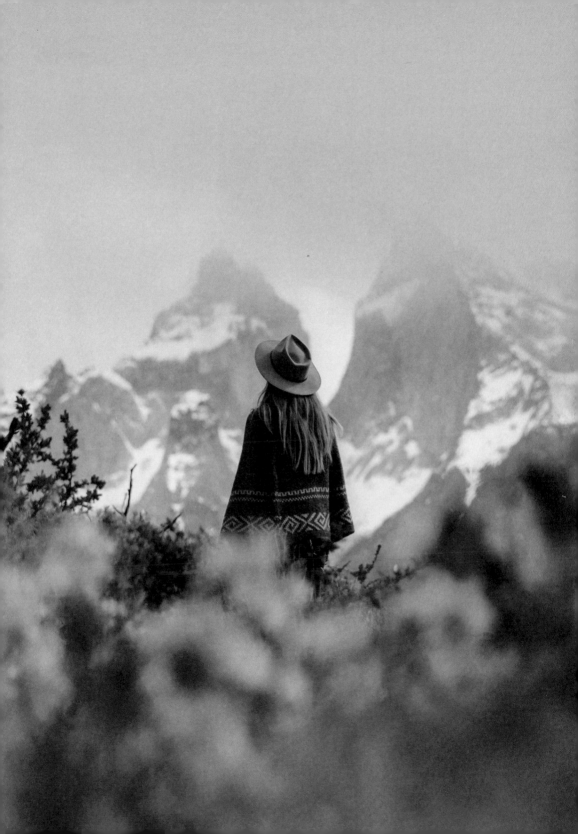

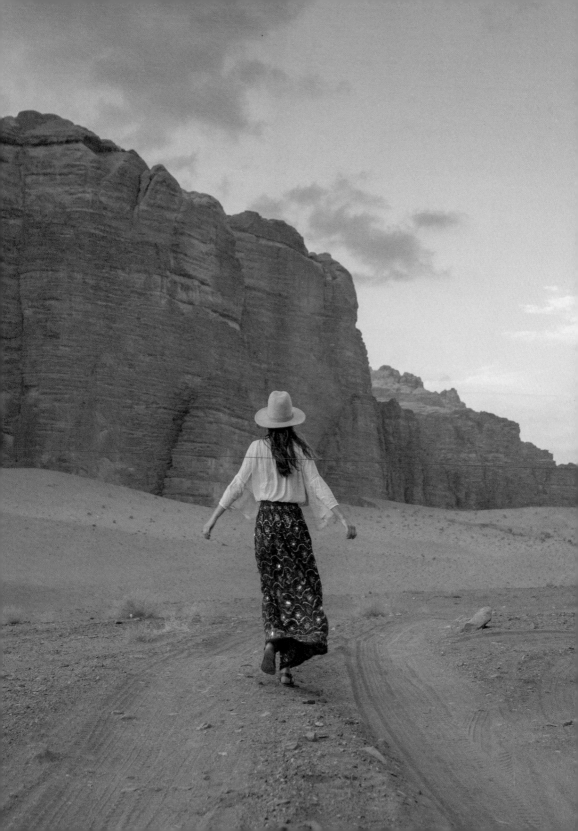

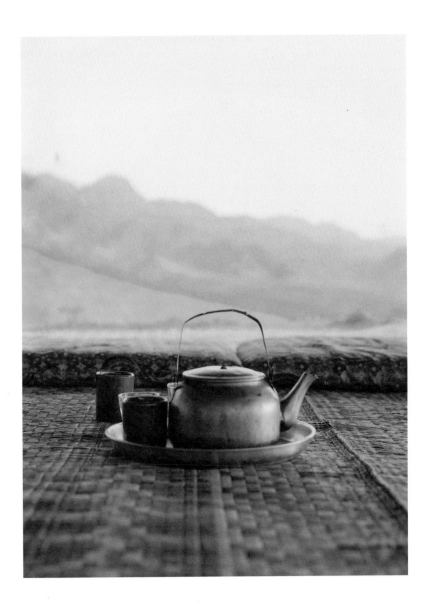

Left As the sun begins to slowly disappear, the sandstone rocks surrounding the Valley of the Moon glows a beautiful deep purple. Wadi Rum, Jordan. **Above** A moment to pause and reflect. Enjoying Arabic tea amongst the rugged and beautiful desert landscape of Wadi Feynan, Jordan.

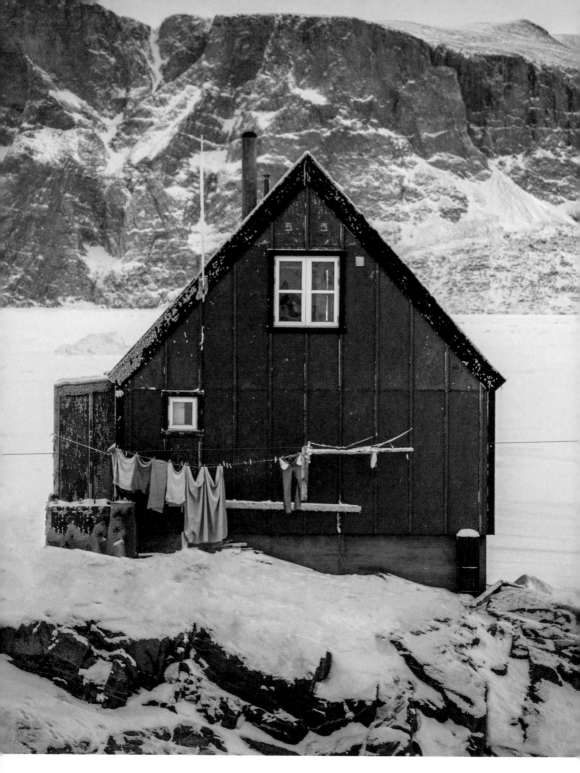

188 A little red house on a remote island in the Article Circle, a frozen yet surreal world surrounded by glacial fjords and temperatures so cold that the entire ocean freezes solid. Uummannaq, Greenland.

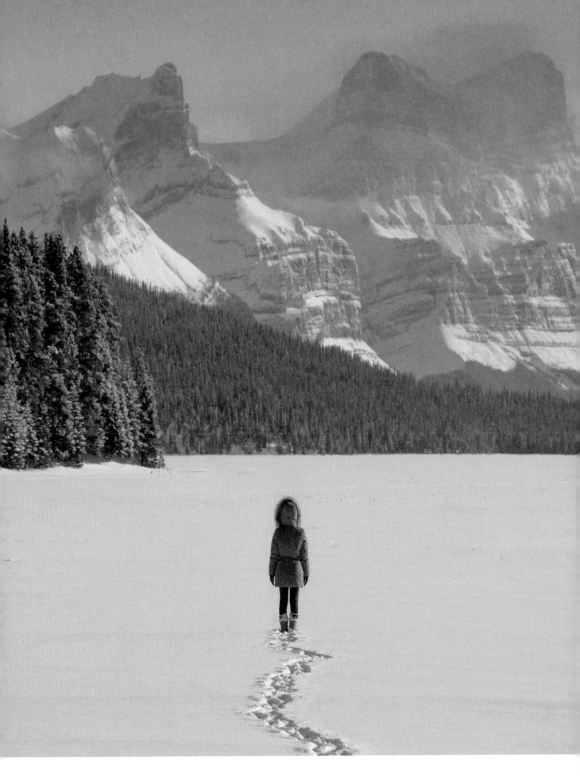

Wandering across a frozen, snow-covered lake surrounded by towering white peaks in a hidden winter wonderland. Jasper National Park, Canada.

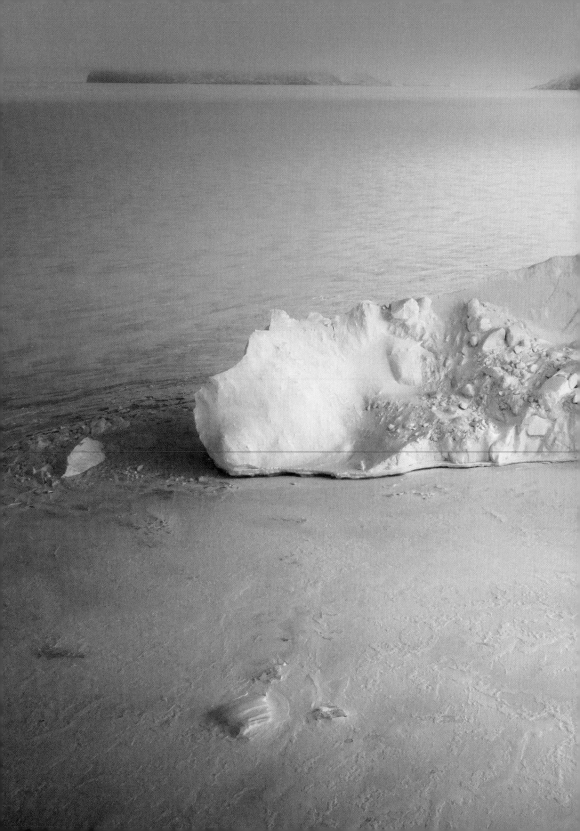

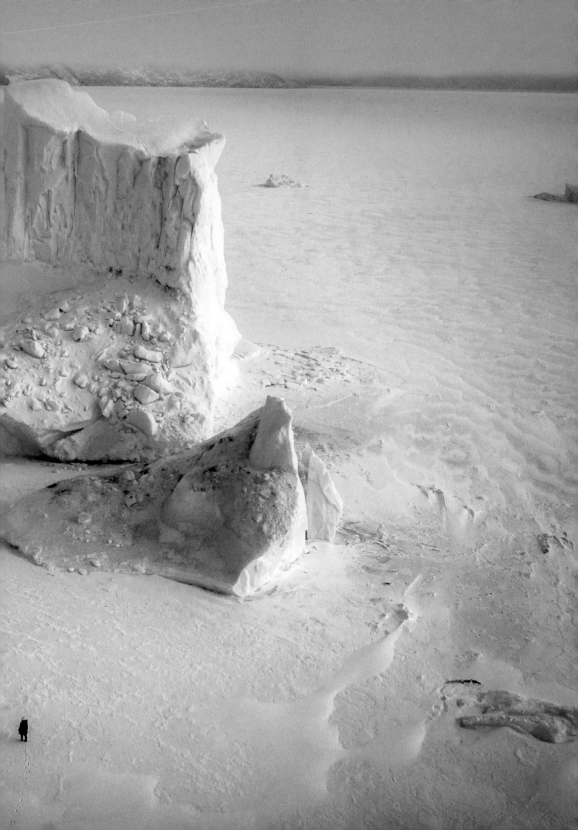

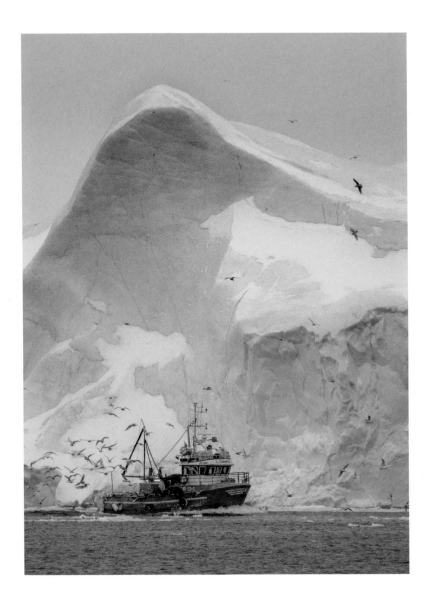

Previous There are certain landscapes that truly allow you to realise how tiny we all really are on this magnificent planet of ours. Standing beneath these remote frozen giants surrounded by an ancient wall of ice, this part of the world has left the deepest mark on my heart. Uummannaq, Greenland. **Left** Notice the little things – observe and search for the curiosities found throughout our wonderful world. **Above** Sailing through a completely frozen world surrounded by hundred-metre-high icebergs floating in every direction – it's hard to comprehend the fleeting beauty of this fragile landscape. Ilulissat, Greenland.

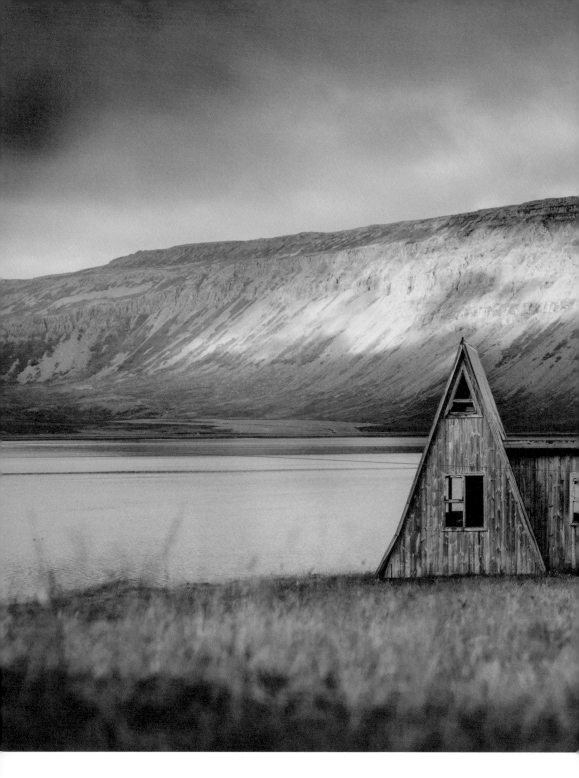

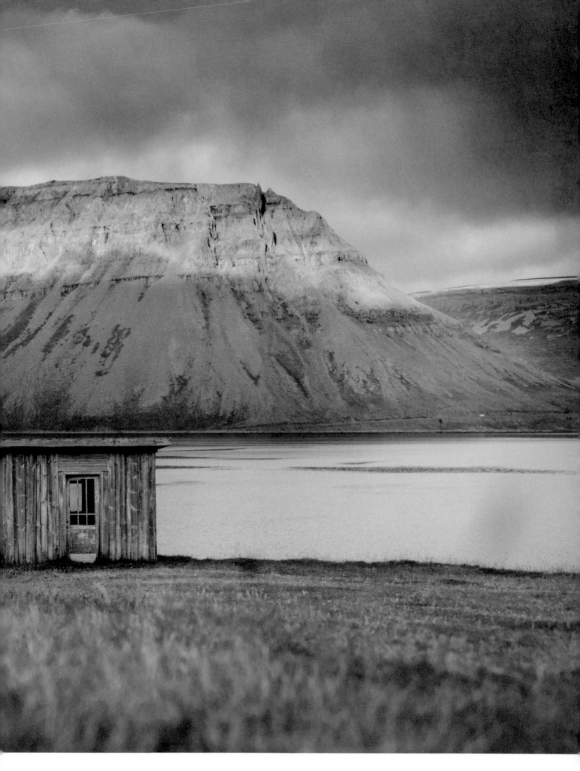

Isolated just outside of the Arctic Circle and hidden within the northern Atlantic Ocean, the Westfjords have a strong heritage and a way of life that's connected to the land and sea. Vestfirðir, Iceland.

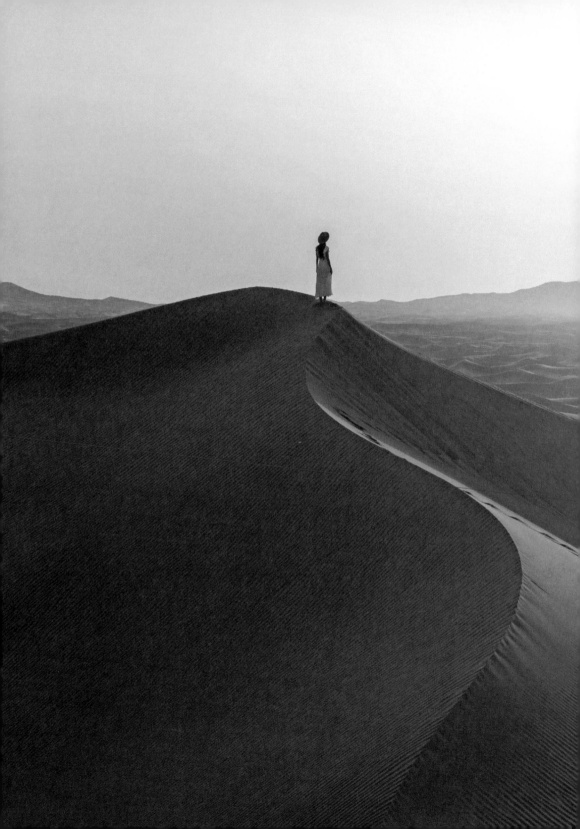

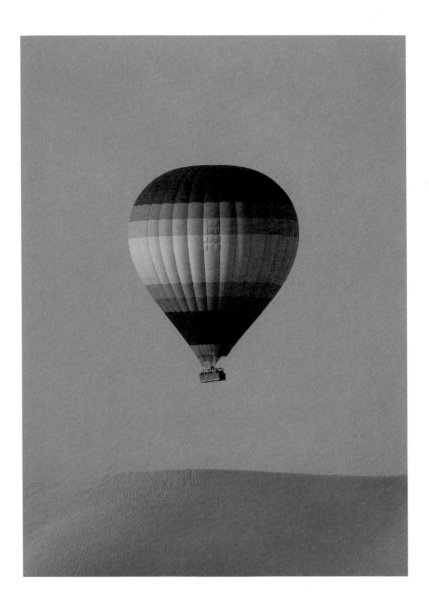

Left Embrace the unknown. There is an overwhelming sense of vulnerability found within these seemingly endless, uninhabited landscapes. Al Qudra Desert, United Arab Emirates. **Above** Floating high above the desert and observing the emptiness of this seemingly desolate part of the world. Arabian Desert, United Arab Emirates.

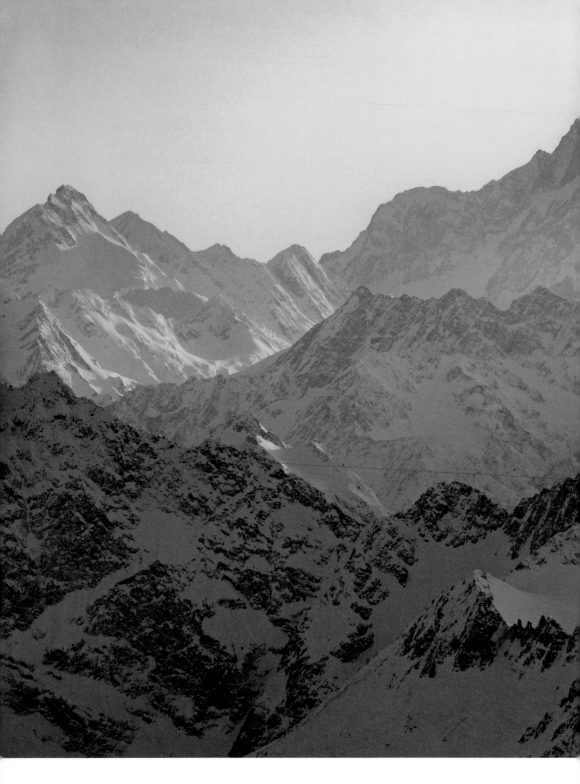

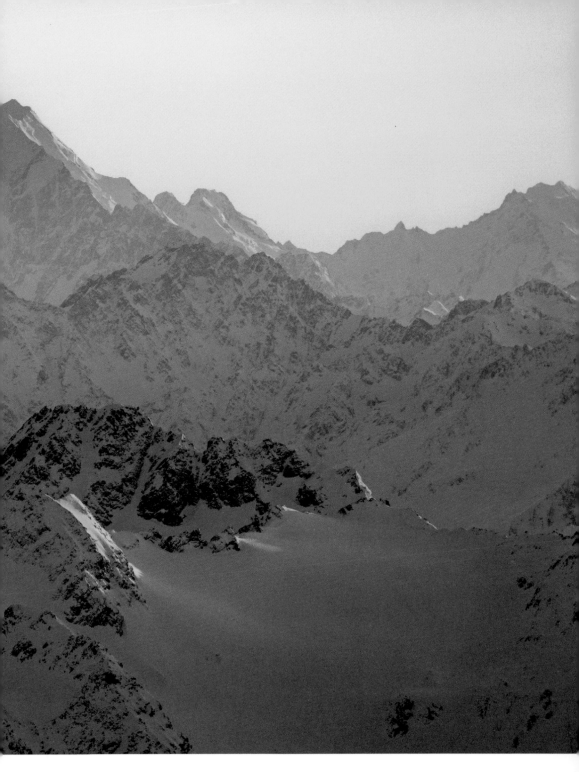

An alpine world of rock and ice – there's a wildness and sheer grandeur to these mountains, an unpredictable and ever-evolving landscape. Southern Alps, New Zealand.

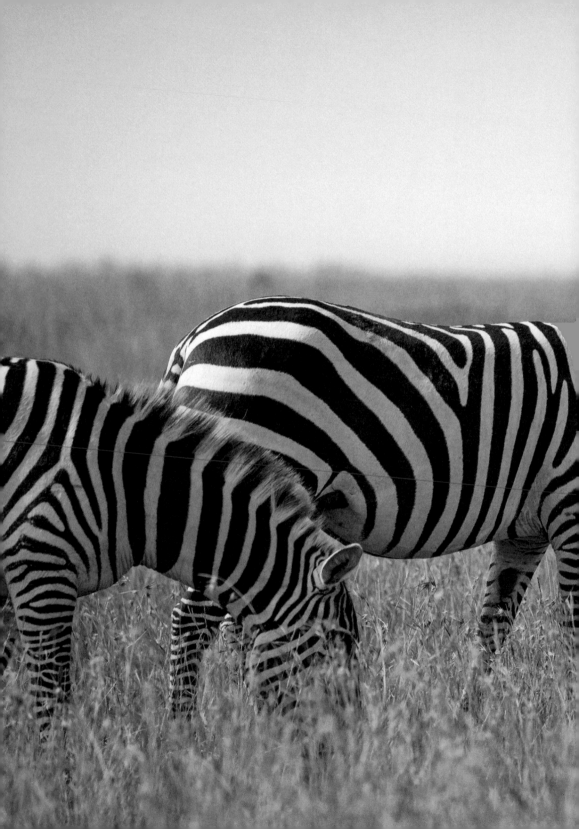

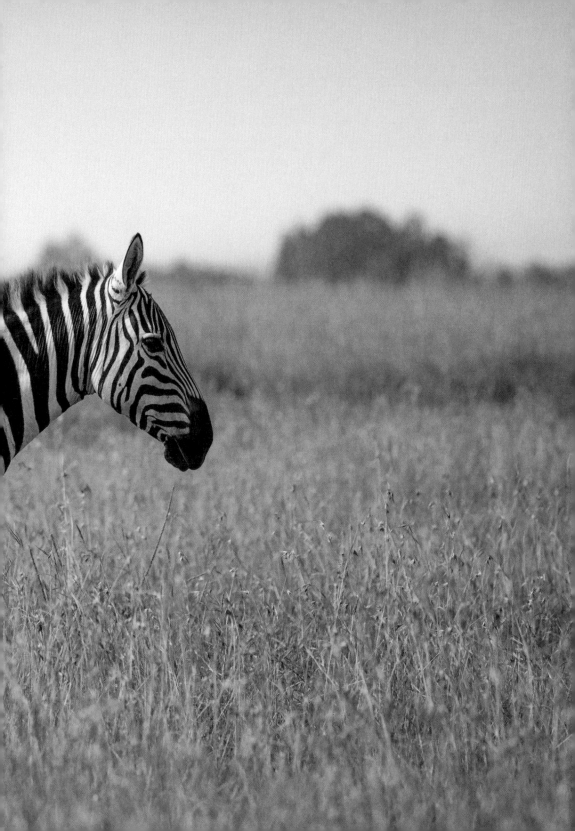

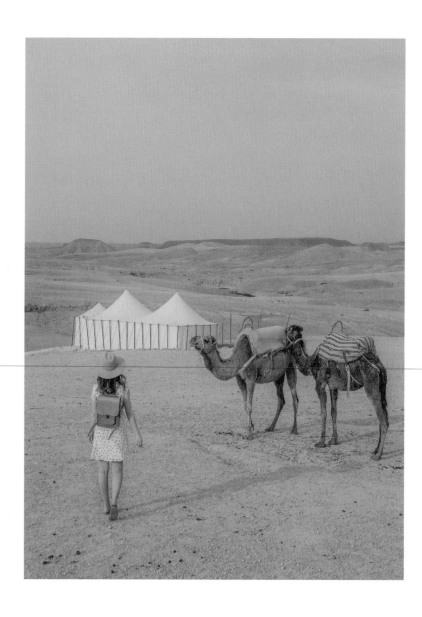

Previous Zebras roaming the dry grasslands of Masai Mara, Kenya **Above** Wandering through a stone-like desert, surrounded by vastness that stretches as far as the eye can see. Agafay Desert, Morocco. **Right** The warm light of a desert moonrise slowly moves across the sky and fills the land with an atmospheric glow. Monument Valley, USA.

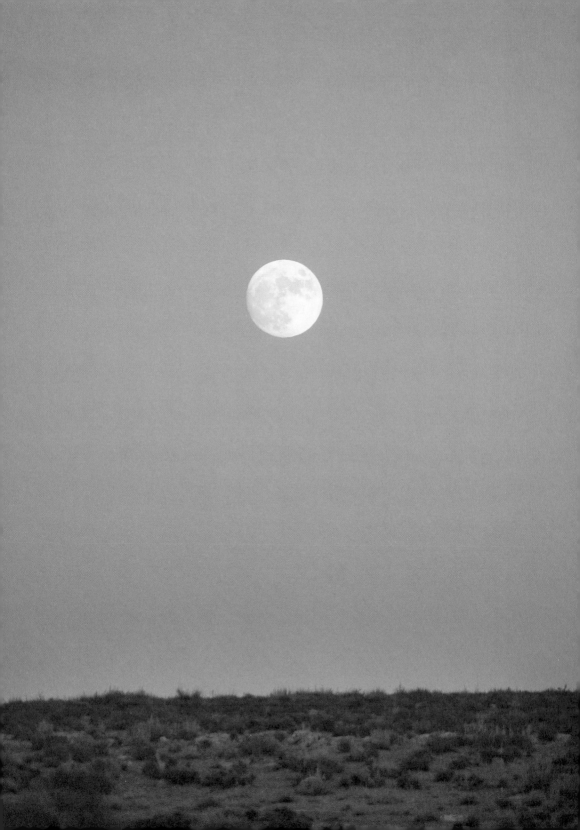

Our natural world is interconnected in more ways than we'll ever know.

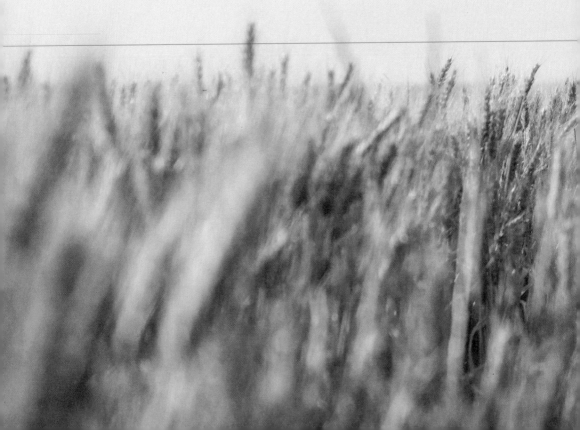

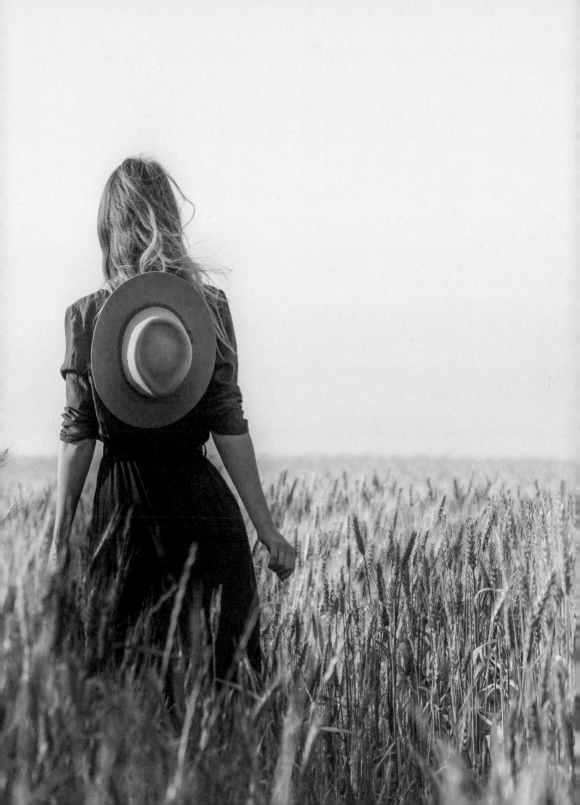

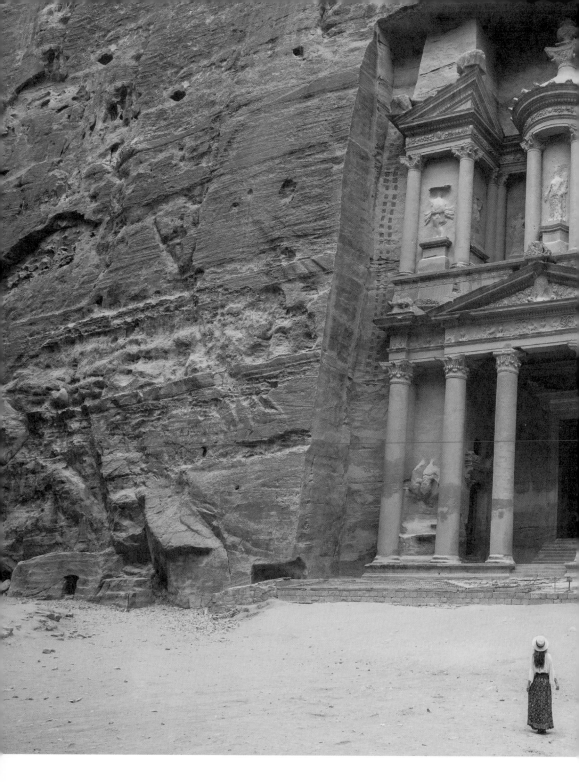

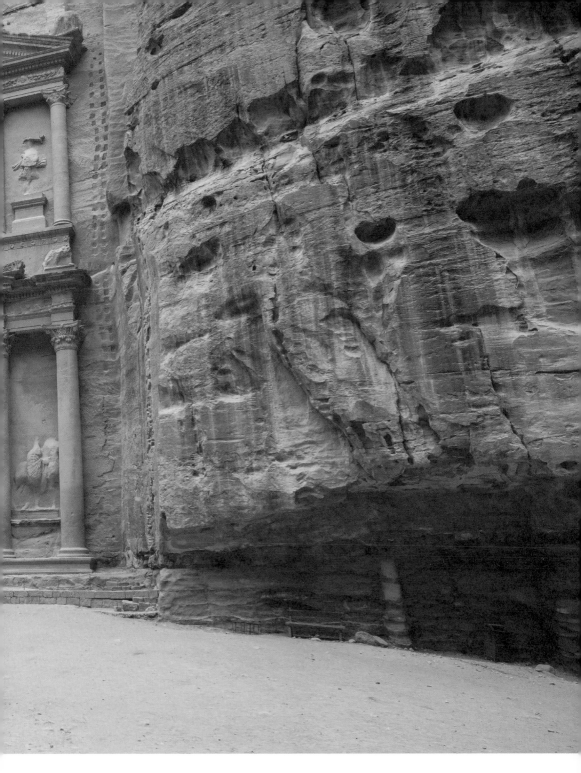

Exploring the intricate temples and caves hidden within the layers of rose-pink sandstone. An ancient wonder that leaves you feeling completely inspired by past civilisations. Petra, Jordan.

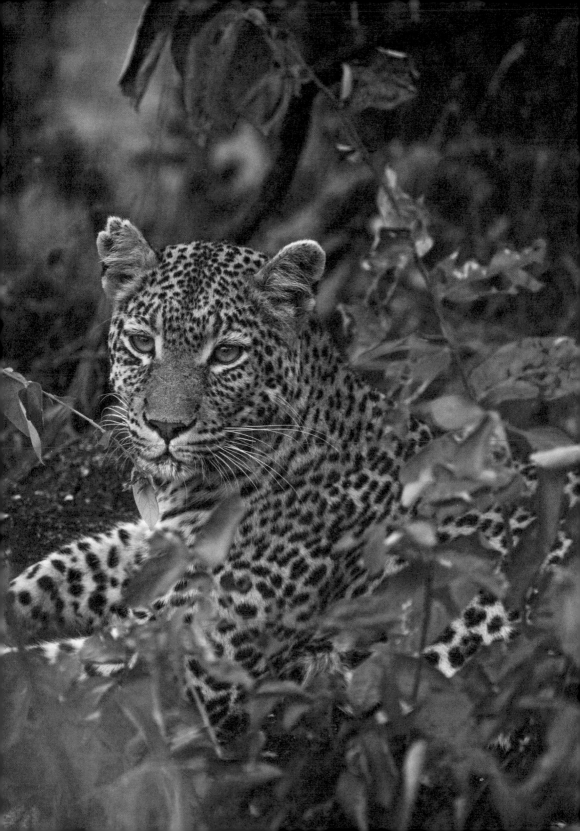

Left Eye to eye with a majestic wild female leopard. These are the encounters in nature that stay with you forever. Kruger National Park, South Africa. **Above** Discover ways to get lost in this wide world of ours; there's infinite possibilities waiting to be explored **Overleaf** There is something magical about watching a moonrise over desert plains. Forever longing for the wild, these wide, open spaces continue to draw me in. Klein-Aus Vista, Namibia.

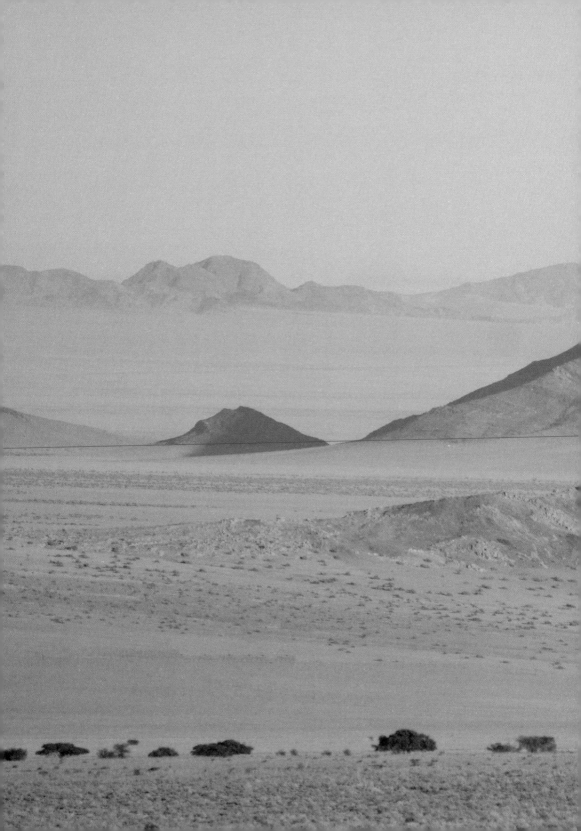

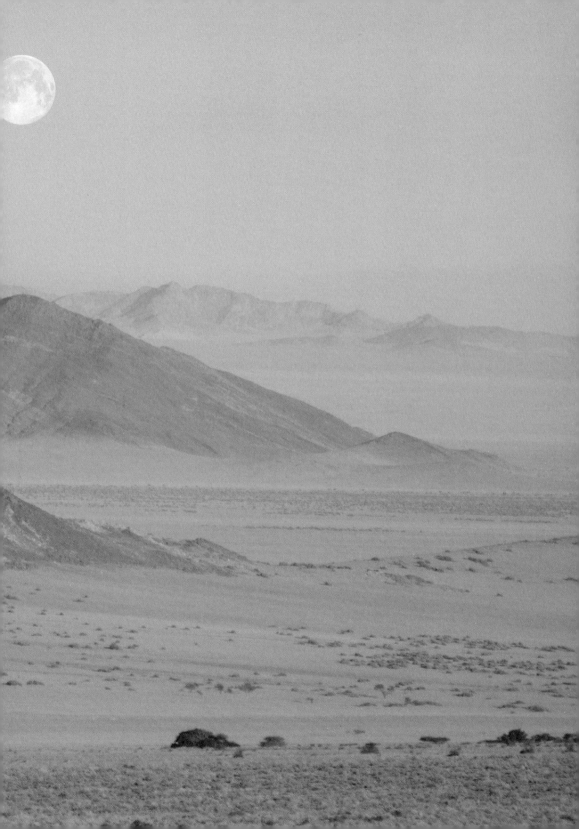

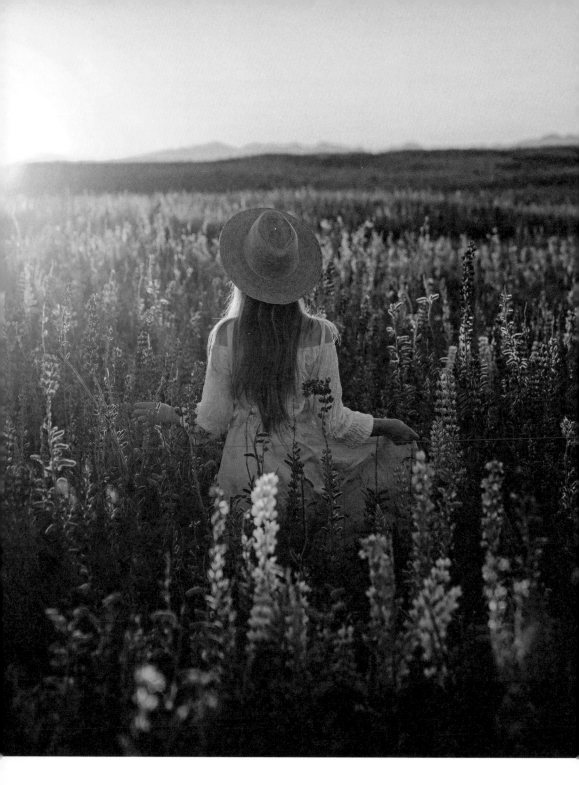

Fields of wildflowers endlessly bloom throughout the open valley plains. South Island, New Zealand.

A window into the past between layers of textures from another time. Tasmania, Australia.

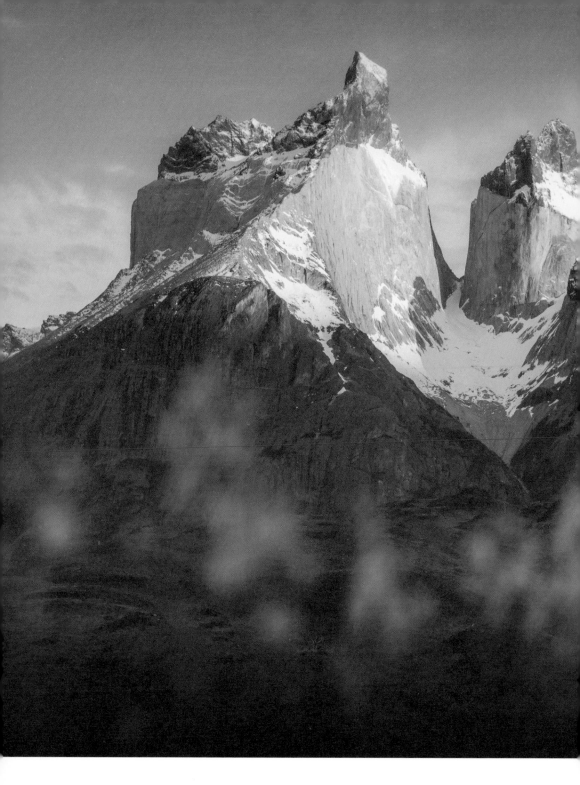

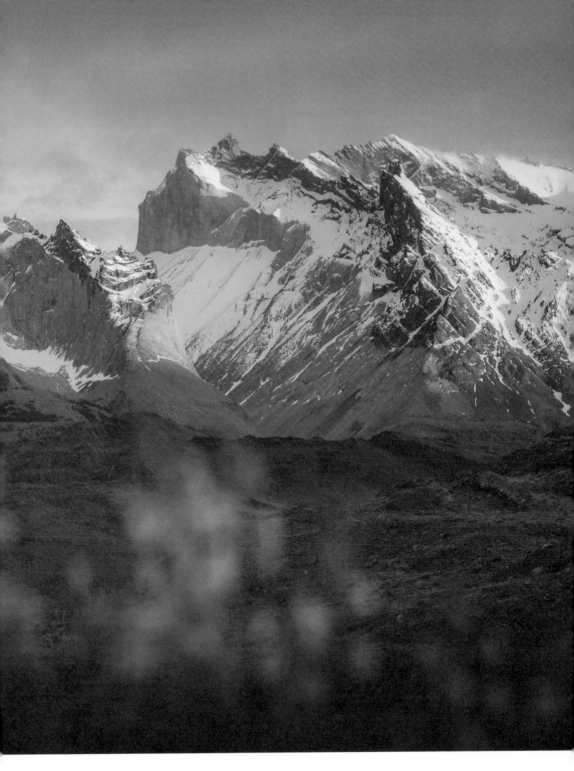

The glow over towering granite peaks and deep valleys in a wild yet fragile landscape that has been transformed by thousands of years of glacial erosion. Torres del Paine, Patagonia.

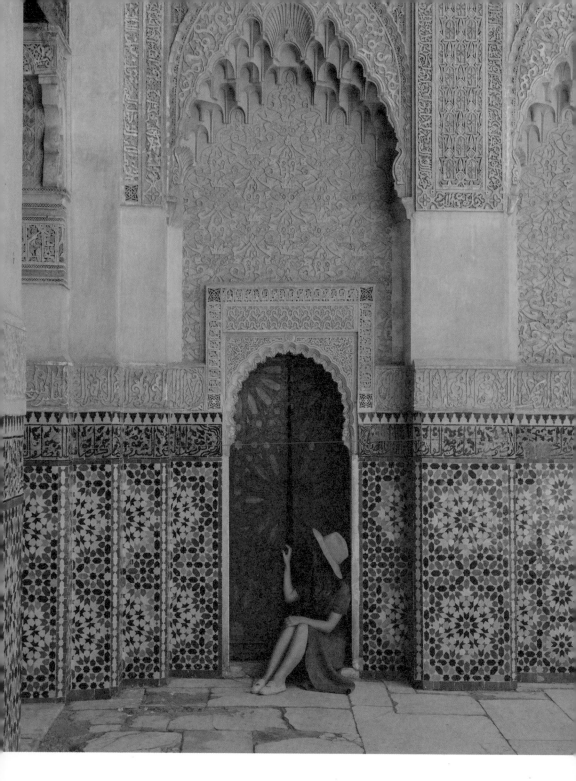

216 A hidden, spellbinding world full of a kaleidoscope of colours, patterns and culture. Marrakech, Morocco.

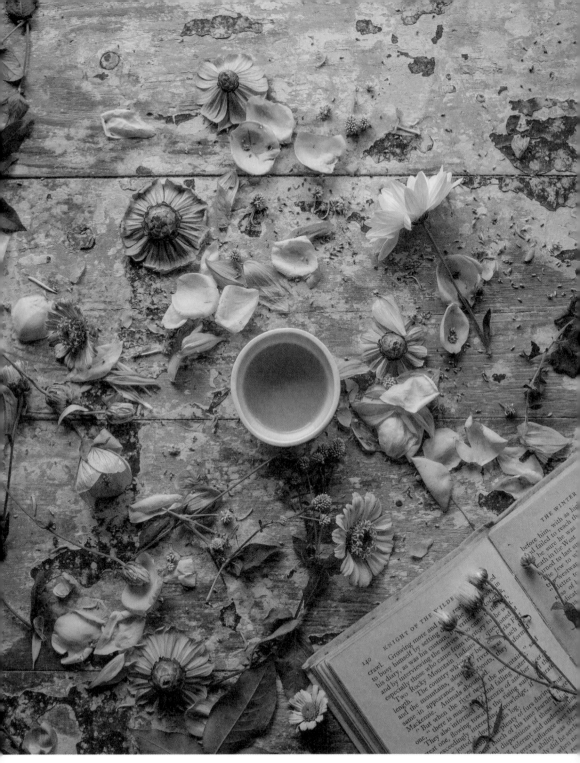

Above A collection of blooming wildflowers – a timely reminder to live slowly and stay grounded. **Overleaf** Time stands still amongst the skeletal trees of Namibia. A silent landscape of rust-red dunes and bleached white river beds, symbolising more than the country's dry and uninhabited expanse; they are places under threat. Deadvlei, Namibia.

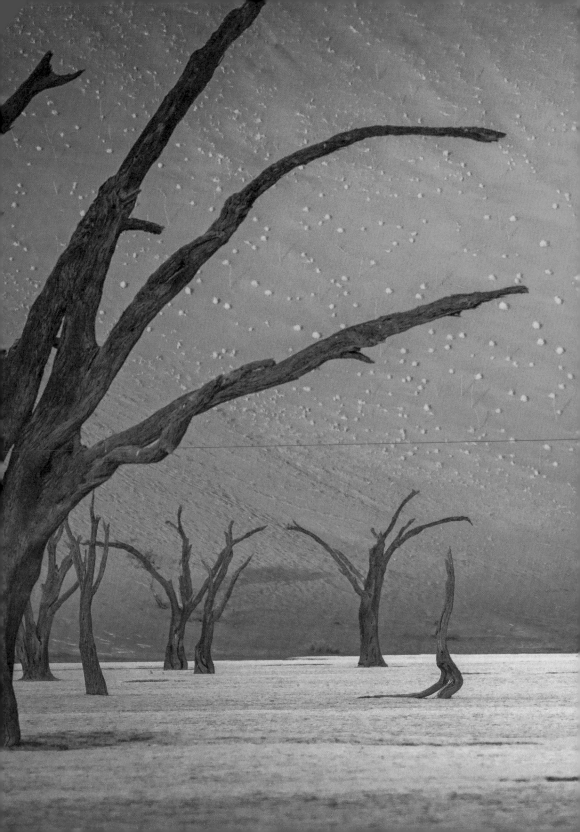

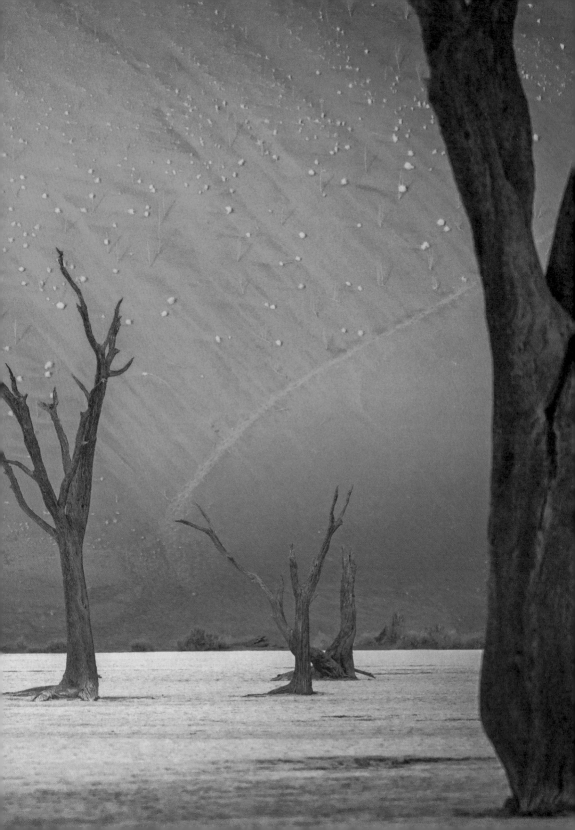

About the author

Wandering far and wide with a camera in her hand, Emilie Ristevski is an Australian photographer and the creative mind behind @helloemilie. With a degree in design and nearly 10 years of professional experience in the creative arts industry, she has a distinctive eye for visual language and communication, specialising in using colour and negative-space to tell stories. Emilie has partnered with some of the world's leading travel and lifestyle brands, including Adobe, Qantas and Canon, and various Australian and international tourism boards.

Built upon natural light and curiosity, her work brings beautiful moments to life through the images she captures. Living between the mountains and the sea on the east coast of Australia, Emilie has formed a strong connection to the natural world. With an innate sense of adventure and a fascination for the unknown, her collection of work documents her appreciation for the natural beauty found throughout the world.

Emilie's work is driven by her need for exploration. Blurring the line between landscape and portraiture, Emilie's work often explores self-portraiture with a sense of ambiguity, searching for the connection between herself and the environment she is in – and allowing the viewer to do the same. Her prominent style of dream-like imagery has led her to explore the diversity of our planet, from remote villages in South America to the wild landscapes of Namibia and Iceland, and everywhere in-between.

Emilie's photography captures the fleeting details that often go unseen. Her imagery and meaningful stories have led her dedicated audience of 1.3 million+ social media followers worldwide to understand the importance of the natural world and the fragility that surrounds our planet. Emilie encourages her community to seek a deeper connection with nature and themselves, in the hope we can all discover a newfound love for the beautiful planet Earth we call home.

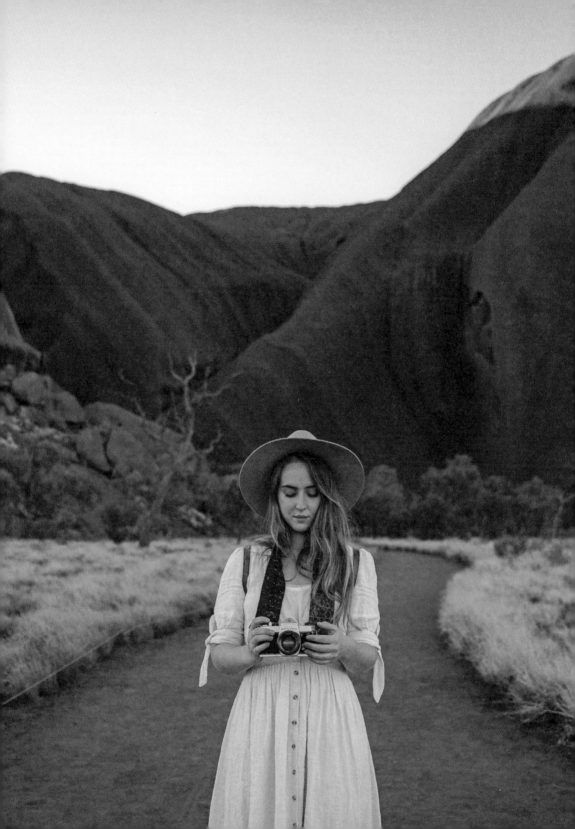

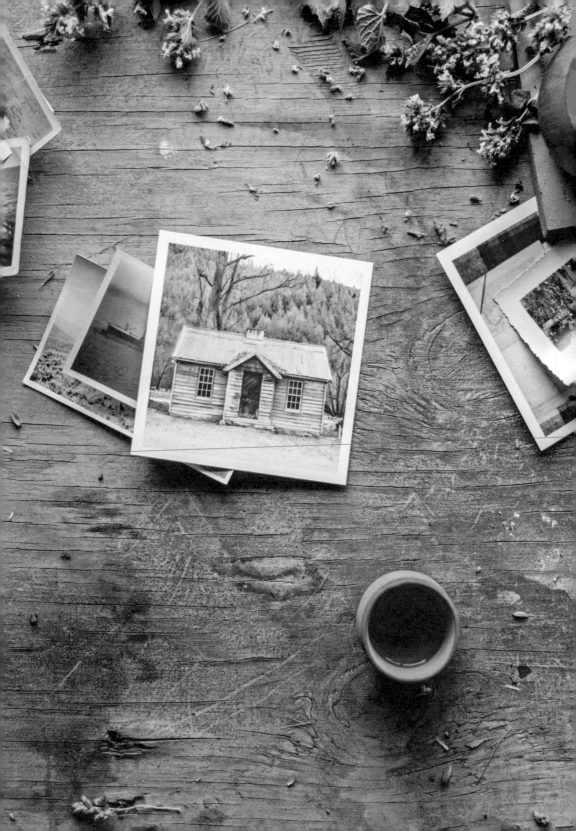

Acknowledgements

Thank you to Melissa Kayser, Megan Cuthbert and everyone at Hardie Grant for giving me this incredible opportunity and for all of the time and hard work you've put into the creation of my very first book – I will treasure it forever. Thank you to the designer, Daniel New, and typesetter, Megan Ellis, for all the hard work and talent that brought each and every detail on these pages together. A very special thanks to Helena Holmgren for all the long hours, dedication and thoughtfulness in her editing that allowed this book to come together so wonderfully.

Thank you to Jason Charles Hill, my partner and fellow photographer. Thank you for the years we've spent experiencing the world and always supporting me both creatively and emotionally. You have allowed so many of my creative visions to become a reality.

Thank you to my loving mother for raising me to appreciate our beautiful planet and shaping me into the person I am today. You've always encouraged me to see the world in a new light, and I would never have been strong enough to see and capture so much of the world without your love and guidance.

Thank you to my followers and everyone who has believed in and supported my work. My career path has been an unexpected and wild journey, and I know none of this would be possible without the constant support from you all. You inspire me to keep capturing the world through my lens.

Published in 2020 by Hardie Grant Travel,
a division of Hardie Grant Publishing

Hardie Grant Travel (Melbourne)
Building 1, 658 Church Street
Richmond, Victoria 3121

Hardie Grant Travel (Sydney)
Level 7, 45 Jones Street
Ultimo, NSW 2007

www.hardiegrant.com/au/travel

A catalogue record for this
book is available from the
National Library of Australia

Hardie Grant acknowledges the Traditional Owners of the country on which we work,
the Wurundjeri people of the Kulin nation and the Gadigal people of the Eora nation,
and recognises their continuing connection to the land, waters and culture. We pay our
respects to their Elders past, present and emerging.

Forever Wandering
ISBN 9781741177190

10 9 8 7 6 5 4 3 2 1

Publisher
Melissa Kayser

Project editor
Megan Cuthbert

Editor
Helena Holmgren

Design
Daniel New

Typesetting
Megan Ellis

Colour reproduction by Megan Ellis and Splitting Image Colour Studio

Printed and bound in China by LEO Paper Products LTD.

The paper this book is printed on is from FSC®-certified
forests and other sources. FSC® promotes environmentally
responsible, socially beneficial and economically viable
management of the world's forests.